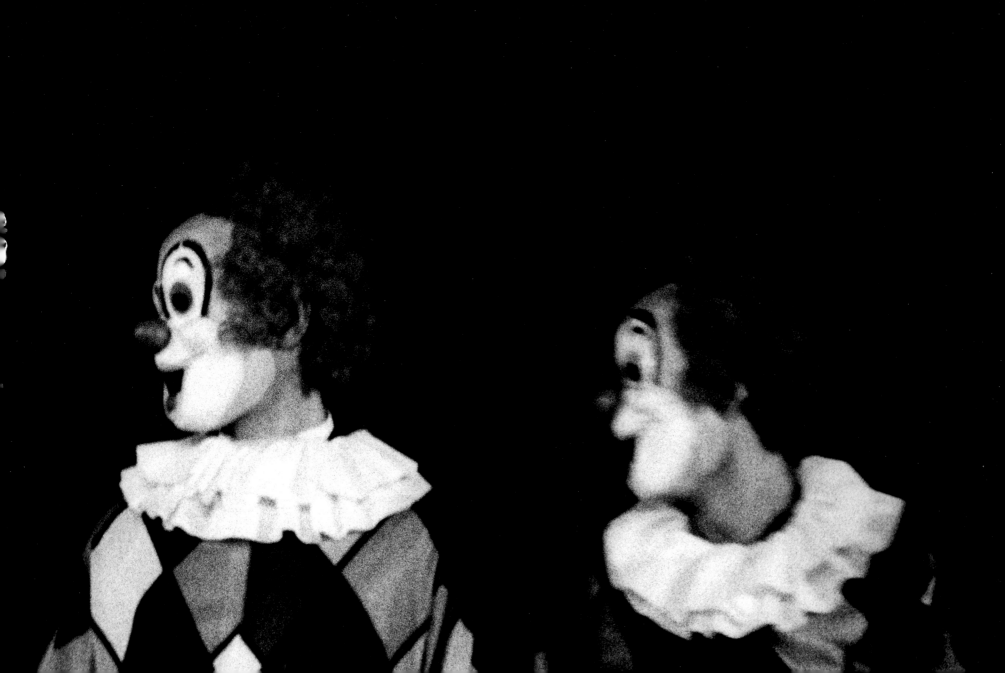

FASHION CIRCUS SPECTACLE

Delaware Art Museum Wilmington

Distributed by the University of Pennsylvania Press Philadelphia

Photographs by Scott Heiser

Contents

Foreword

Significant artists occasionally slip out of the history books and the public consciousness through no fault of their own. Howard Pyle, a household name at his death in 1911, is barely mentioned in the annals of art history today. With the exception of a small and devoted circle of illustrators and admirers in Delaware, the vast majority of people have no idea of the magnitude of Pyle's contribution. The same can be said for another Wilmington native, the photographer Scott Heiser, who, like Pyle, straddled the boundary between fine and commercial art and who has also been largely forgotten since his untimely death in 1993.

With such artists of merit it becomes the job of the intrepid museum curator to "rediscover" and reposition the artist within the narrative of art history. This generally takes an enormous amount of effort and ingenuity. Heather Campbell Coyle, the Delaware Art Museum's curator of American art, first came across a group of Scott Heiser's photographs while conducting a routine inventory of the collection in 2005. Intrinsically compelling, Heiser's photographs immediately captured her attention because they were completely unlike the rest of the Museum's photography holdings, which contain mostly documentary works by well-known photographers such as Leon Levinstein, Garry Winogrand, or Sebastião Salgado, or textbook examples by major artists such as Ansel Adams and Imogen Cunningham.

Who was Scott Heiser and how did the Museum come to acquire these intriguing pieces? In 2009 Dr. Campbell Coyle set out to answer that question and resolve the mystery. A cursory search of Heiser's name online revealed his obituary published in the *New York Times* on October 23, 1993. Titled "Scott Heiser, Leader and Innovator, 44, in Fashion Pictures," the obituary made it quite clear that the photographer had had a noteworthy career before his premature death. It also indicated that Heiser had been born and raised in Wilmington. Research into the Museum's databases showed that the donor of the photographs, Scott's mother, Mary G. Heiser, was still an active Museum member living in the area. A call to Mrs. Heiser led to a connection with the artist's dear friend Thomas Woodruff, who had preserved a large collection of Heiser's photographs. With help from Mr. Woodruff and Mrs. Heiser, Dr. Campbell Coyle was able to track down (via Facebook!) Marc Balet, the former art director of *Interview* magazine, where Scott Heiser had worked. More names of associates and friends followed.

After reviewing a group of fifty photographs from Mr. Woodruff, Dr. Campbell Coyle began to envision an exhibition. With the help of a curatorial research grant from the Andy Warhol Foundation, she was

able to spend some time in New York researching Heiser. Over the course of the next two years, Dr. Campbell Coyle was hot on the trail, interviewing Heiser's friends and associates and making more than a dozen trips to New York to visit the New York Public Library, the Fashion Institute of Technology, and other resources. Two research assistants, Jane Tippet and Maeve Coudrelle, supported by the Warhol Foundation grant, helped to track down sources and individuals and to perform and transcribe interviews. In 2011, a chance encounter put Dr. Campbell Coyle in touch with Stephen Petersen, an art historian who had just finished the catalogue celebrating the Warhol Foundation's gift of photographs to the University of Delaware. He was the first person outside of Heiser's circle of friends and family to immediately recognize Heiser's name and remember his significance to *Interview* magazine. Dr. Petersen became the natural choice for a guest author for the exhibition catalogue.

Last spring, Dr. Campbell Coyle finished the research and interviews and even started a Facebook page dedicated to the photographer to encourage his friends to share images and reminiscences. She also traveled to Mr. Woodruff's home and gathered a "first cut" of about 140 photographs, as well as archival materials like Heiser's tear sheets, letters, account book, passports, and press passes. These materials, along with the interviews, helped to piece together the artist's extensive and remarkable career. Finally, with a clearer picture of this career emerging, the curator was able to select eighty works for exhibition and begin the labor associated with molding all of this vast original research into a compelling narrative of Scott Heiser's life and work.

This labor of love, taking over five years to complete and undertaken in the midst of many other commitments, exemplifies the way that bold and determined curators like Heather Campbell Coyle do the work of creating knowledge. What started out as a curious moment during a routine inventorying process became a passionate pursuit to reclaim a forgotten artist whose work deserves to be known. This kind of work—expensive, time-consuming, and at times frustrating—exemplifies the Museum's mission to preserve and interpret at its best.

Danielle Rice
Former Executive Director
Delaware Art Museum

Acknowledgments

I wish I had known Scott Heiser. The enthusiasm and generosity shown to me by his friends, family, and associates testify to the deep impact Heiser had on those around him. I am profoundly grateful to Mary G. Heiser, the artist's mother, and Thomas Woodruff, his close friend. They preserved the artist's photographs and generously shared these with the Museum. They also shared their knowledge and memories and steered me toward others who cared deeply about Heiser and his work. Without their participation, this exhibition and catalogue would not be possible.

Heiser's many friends helped me to understand his career and his character. I thank Hilton Als, Marc Balet, Mickey Boardman, Beth Claverie, Nancy Carey, Herman Costa, Nancy Hall, Kim Hastreiter, Bernice Mast, and Deborah Turbeville for answering my many questions and sharing stories, photographs, and films. Your insight helped me to better understand your friend and his work. It was the next best thing to being a fly on the wall on Benefit Street.

This project has profited immensely from Stephen Petersen's expertise in the history of photography and film. Providing key research and feedback on the checklist and my essay, he has been a generous contributor to this project. Research assistants Jane Tippett and Maeve Coudrelle tracked down bibliographic materials. Ms. Coudrelle also provided translation and assisted with interviews and selection. Her enthusiasm kept this project moving forward when I was swamped with other responsibilities. Contributions from Hilton Als and Thomas Woodruff provide a vital human dimension to balance the art historical story told in the catalogue essays.

A curatorial research grant from the Warhol Foundation launched this project. At the Delaware Art Museum, the unflagging support of former director Danielle Rice and chief curator Margaretta Frederick was vital in the completion of this exhibition and book, as was the day-to-day assistance of chief registrar Erin Robin. As always, editor Carolyn Vaughan and the team at Marquand Books made this a better publication than I had imagined. Zach Hooker and Jeff Wincapaw prepared an elegant presentation that echoes the artist's velvety prints.

Heather Campbell Coyle
Curator of American Art
Delaware Art Museum

Available Light

Light

HEATHER CAMPBELL COYLE

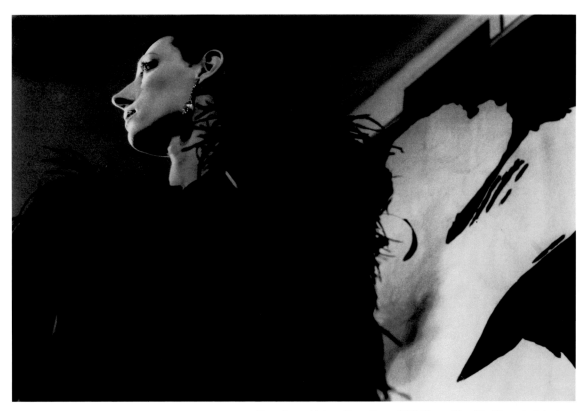

Fig. 1. Scott Heiser, **Sara Kapp (Bill Blass, New York),** 1978. Gelatin silver print, 6 × 9 inches. Estate of the Artist.

A striking woman looks away from the camera, her distinctive nose and perfect jaw in profile. Seen from below, she is iconic and frozen, like a mannequin in a shop window. Her face occupies only a small part of the frame—most of the image is given over to the velvety black mass of her feathered jacket and a decorative screen behind her. With broad white strokes on a dark background, the screen mirrors the plumes of her jacket, balancing the composition, while the midtones that define her face contrast with the play of stark black and white in the other elements. Scott Heiser's *Sara Kapp,* 1978, is a wonderful photograph, but a strange portrait (fig. 1).

Yet in the fall of 1982, it was included with nine other photographs by Heiser in *Faces Photographed: Contemporary Camera Images* at the Grey Art Gallery of New York University. The exhibition, organized by Robert Littman and Ben Lifson, featured recent portraits by the high-profile con-temporary artists Cindy Sherman, David Hockney, Nan Goldin, and John Coplans, and photographers associated with fashion and celebrity, like Arthur Elgort, Bruce Weber, and Heiser, then best known for his fashion photographs in *Interview* magazine. As the critic Charles Hagen noted in a review for *Artforum,* "The photographs here are portraits of one sort

or another, but despite the show's title, few have all that much to do with faces." Instead, he argued, the photographers "employ—but do not confront—various forms of stylization, both photographic and personal, and the fictive personas created by photographers and their subjects for fashion and magazine illustration."[1] *Sara Kapp* certainly fits that description. Kapp was a fashion model and a celebrity, famous enough to have a mannequin sculpted in her likeness. And though it was presented at the Grey Gallery as a portrait, Heiser's photograph had been taken at a fashion show a few years earlier. It first appeared in print captioned *Bill Blass* and featured in a photo-essay titled "Runway: New York" in *Interview.*[2] It is not, strictly speaking, a portrait at all.

Nor is it, in a traditional sense, a fashion photograph. It does not highlight the clothing, and the model is more easily recognized than the ostrich-feather jacket she wears.[3] Of Heiser's ten works in the show, dating from 1976 through 1981, *Sara Kapp* was the only picture not originally produced as a portrait, yet it was the image selected to represent him in the exhibition catalogue, perhaps because runway photographs were what Heiser was best known for in 1982.

Retitled *Sara Kapp* and reprinted on creamy, matte-finish paper, Heiser's photograph passes for portraiture, even art. For Hagen, Heiser's compositions evoked "turn-of-the-century Photo-Secession pictures"— photographs that consciously emulated the look of prints and paintings and that were receiving attention from art historians and collectors in the early 1980s.[4] Another reference to art exists within the frame. The screen behind Kapp—part of the backdrop for the fashion show—is decorated with an enlarged image of brushstrokes. Rendered black and white in Heiser's photograph, the backdrop recalls the abstract expressionist marks of Franz Kline, even as its flatness conjures Warhol's screen-printed canvases. Whether read as abstract expressionism or pop art, the large-scale brushstrokes signify as art, although they were produced to decorate a fashion runway. In New York around 1980, art, fashion, photography, and celebrity intermingled, allowing *Sara Kapp* to appear in multiple contexts and trigger rich associations. Scott Heiser (1949–1993) operated at the fascinating convergence of interests and influences that characterized this dynamic moment in American culture.

In Training: Background and Education
Born and raised in Wilmington, Delaware, Heiser was interested in art and design. His talent stood out in high school. His mother recalls visiting a student art exhibition where most of the young artists displayed carefully rendered portraits and landscapes. Heiser's art teacher greeted her enthusiastically and brought her to see her son's distinctive contribution: a close-up drawing of a knot in a tree trunk.[5] His teacher's opinion was

validated: Heiser was accepted to the Rhode Island School of Design. In 1967 he entered as a graphic design major and developed an interest in fashion illustration.

Later in life, Heiser particularly valued his studies with Richard Merkin, a longtime painting professor at RISD, who has been described as "an exemplary artist/rebel/dandy persona who placed equal creative emphasis on his painting, illustrations, journalism and, of course, raiment."[6] Merkin was particularly attracted to styles of the 1920s and 1930s, and his class assignments included leafing through old magazines. These publications, with photographs by Edward Steichen and Cecil Beaton, appealed to Heiser, who eventually switched his major to photography. Merkin's assignments may have helped focus Heiser's attention on fashion, and his influence lingered in Heiser's photographs. For a self-portrait assignment at RISD, Heiser dressed up for the camera in a checked jacket, flowered tie, and rakishly angled boater, transforming himself into a dandy—a trick he acknowledged with a half smile (fig. 2).

More frequently at RISD, Heiser's interest in fashion played out in photographs of his friends. According to an art-school friend, Heiser was more "interested in the effect of fashion on women" than in contemporary clothing.[7] He befriended individuals with distinctive fashion sensibilities, including women who (like Merkin) favored vintage attire, and he collaborated with them for his photographic experiments.

In RISD's photography department, headed by Harry Callahan, Heiser completed typical student assignments—lighting and photographing a pewter jug, taking pictures of pigeons in a city park, making self-portraits—as he developed his own aesthetic and interests. Callahan's goal, especially in his senior seminar, was for each student to develop an individual approach, and though Heiser may not have agreed with all of Callahan's critiques, he spoke of his professor with respect.[8] Heiser's personal style is apparent in photographs of his friends, produced with a 35mm single-lens reflex camera, available light, and long exposures. With his art-school associates conscripted as models, Heiser traveled to old mansions and barns to shoot pictures, as well as spontaneously photographing his friends in their apartments on Benefit Street. For one session, he and his model arrived at an abandoned house in Providence just after dawn to capture the mist coming off the grass (fig. 3). For others, he covered his lens with nylon to create a dreamy, soft focus in indoor photographs.[9] Heiser directed some of these efforts "quite specifically . . . very little was left up to chance," and he enhanced the effects in the darkroom, pushing grain and contrast.[10]

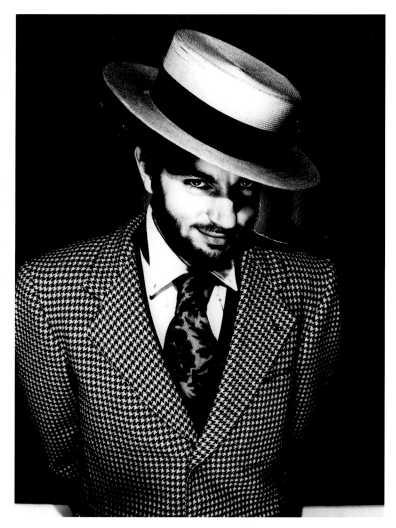

Fig. 2. Scott Heiser, **Self-Portrait,** 1971. Gelatin silver print, 8¾ × 6¾ inches. Mrs. Mary G. Heiser.

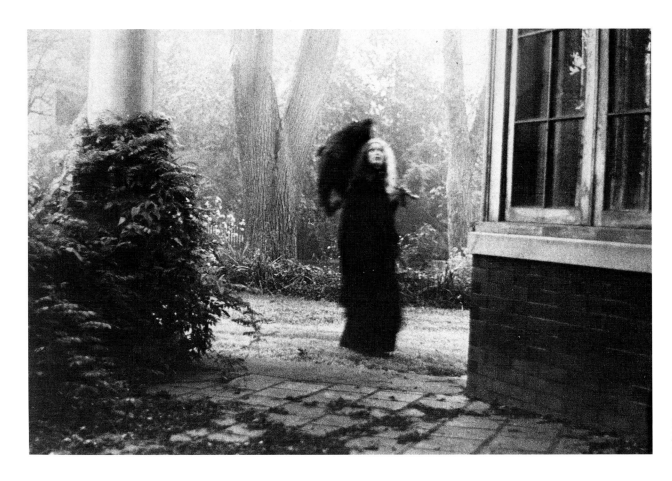

Fig. 3. Scott Heiser, **Untitled,** c. 1970, in *35mm Photography,* Spring 1974, p. 78. Printed Matter. Helen Farr Sloan Library, Delaware Art Museum.

In Print: Launching a Career, 1971–1976

After graduation in 1971, Heiser headed to New York City, where he worked for a cab company, an answering service, and temporary employment agencies as he began building a career as a photographer. He developed film and made prints for illustrators and photographers, and he photographed textiles and accessories. A skilled printer, Heiser set up a darkroom in his closet and became adept at working with limited means. He found his earliest clients for darkroom work in his social circle; in the seventies, he developed and printed for Merkin, the artist Herman Costa, and the fashion illustrator Albert Elia.

In New York Heiser also sought work assisting successful photographers. He worked for the magazine photographer Steen Svensson and set up an interview with Diane Arbus, whose work he admired immensely, before finding regular work with Deborah Turbeville.[11] A former art editor for *Mademoiselle,* Turbeville was just beginning her career as a fashion photographer when she hired Heiser as her assistant early in 1973. Turbeville recalled being introduced to Heiser through Elia, a fashion illustrator and instructor at the Parsons school of design, who was at the center of a group of young artists and designers making films in New

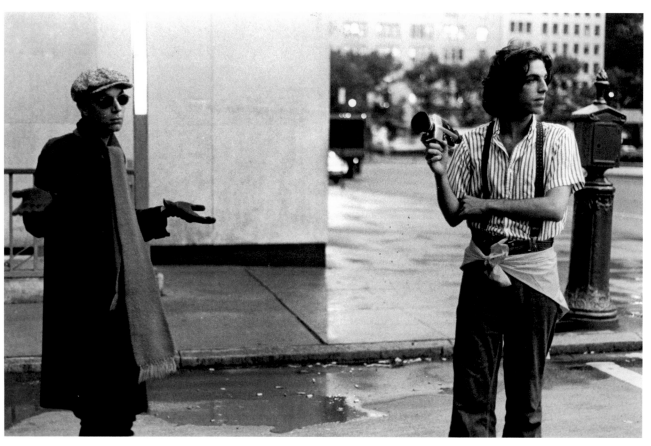

Fig. 4. Bernice Mast, **Scott Heiser (in Chauffeur Costume) and Marc Balet (with Camera), New York,** 1973. Gelatin silver print, 6¼ × 9½ inches. Scott Heiser Papers, Delaware Art Museum. © Bernice Mast 1973.

York (fig. 4). Turbeville was attracted by Heiser's photographs of "girls in costumes" and "old mansions in Rhode Island." She was impressed that he already had a personal vision—one that paralleled her own interest in "blurred images" and "narrative things."[12] They may have shared an admiration for the French fashion photographer Sarah Moon, whose romantic, softly focused images were just beginning to appear in magazines. They certainly shared a passion for atmosphere, a sense of "mystery, a story," which Turbeville has described as "the main thing about my pictures."[13]

When Heiser began to work for her early in 1973, Turbeville was still new to photography, having begun to take pictures seriously in 1970. She was "testing" and "working on special stories," developing her skills and her aesthetic. Heiser assisted her with technical matters: his ledger records frequent payments for darkroom work, as well as on-site assistance for Turbeville's shoots over the next two years. Although he was interested in using natural light (as was Turbeville), Heiser had been trained in traditional methods of lighting, and he did some lighting for her, as well as black-and-white printing. He was particularly engaged in the creative, experimental projects that Turbeville embarked on in the early 1970s.

In the years Heiser worked for her, Turbeville rapidly rose in prominence from a novice to one of the most talked-about fashion photographers of the day. Her atmospheric pictures placed models in unusual settings and inexplicable arrangements. In a series of images for the innovative magazine *Nova*, she arranged four models—three women in related attire and a slender man in a singlet—in a garden at Clevedon, England. Their contrived poses recall ballet or modern dance, and watching over them like a choreographer stands Richard Merkin, smoking, in an impeccable suit (fig. 5). Perhaps her most famous photographs of the 1970s feature wan women in bathing suits, posed in a turn-of-the-century, tiled bathhouse in New York. The women's pallor and expressions—they do not smile, they do not look at each other—and enigmatic setting left *Vogue*'s readers to wonder if they were drug addicts, wards of an insane asylum, or victims in a concentration camp.[14] Especially when published in a series, her photographs seemed to imply a narrative, or at least an occurrence, but the viewer was left to create a story.

By 1975, Turbeville was receiving major assignments from American *Vogue,* and Heiser's interest waned. "The sittings were real productions because of the way I wanted the pictures to look," she explained, and the drawn-out shoots, with many people on set, left Heiser irritated. To Turbeville, who has positioned herself outside the mainstream of fashion photography, Heiser seemed antagonistic to the commercial realities of the field. "He was just not the kind of person that could be bothered by these clients, these advertising executives, and the whole drama of the fashion world, with people around him, while he was taking his pictures."[15]

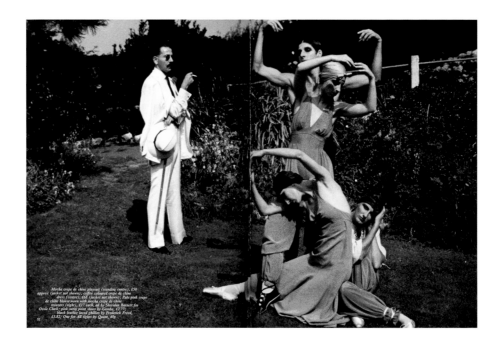

Fig. 5. Deborah Turbeville, **Untitled,** 1973, from "A Touch of Ballet Class," in *Nova,* December 1973, pp. 52–53. Printed matter. Helen Farr Sloan Library, Delaware Art Museum.

Heiser was also moving beyond work as an assistant. In 1972, he recorded his first published commission from *Interview* magazine, and in the next few years he received occasional work from magazines and designers.[16] In 1974, *Interview* presented an exciting opportunity, sending Heiser to photograph and interview the painter Jamie Wyeth, already a famous artist and an acquaintance of the magazine's founder, Andy Warhol (Wyeth and Warhol would become closer in 1976). Titled "Down on the Farm with Jamie Wyeth," the interview took place on Wyeth's Chadds Ford, Pennsylvania, farm, less than twenty miles from where Heiser was raised in Wilmington.[17] Heiser's approach to this assignment, visiting the artist at his home, was appropriate for Wyeth, whose practice as a portrait painter was to paint his subjects in their own environments. In the interview, Wyeth seems relaxed and confident, describing his isolated summers in Maine, his active life in New York, and his farm and studio in Chadds Ford, and Heiser's portraits of Wyeth—in the landscape, among his pigs, seated on the stoop of his old house—provide a fitting companion to the character that emerges in the text (fig. 6). The painter looks young and unaffected, and both photographer and subject were pleased with the result.[18]

By the spring of 1974, Heiser's experimental photographs also began to appear in print. *35mm Photography* (an offshoot of *Popular Photography*) published four of his submissions in their portfolio section "Gallery 35," alongside emerging photographers like Ralph Gibson and Ralph Nykvist. Even in reproduction, Heiser's images stand out for their atmospheric focus, while sharing a grainy quality and a sense of mysterious, interrupted narrative with Gibson's sunlit pictures of the Mediterranean. Later that year Heiser's work appeared in *Invitation to Photography*, and he was profiled as an upcoming photographer in *Art Direction* in 1976, represented by four photographs, including an advertisement for Giovanni de Moura (fig. 7).[19] For the de Moura shoot, Heiser arranged disconnected figures on two distinct planes within an elegant interior, where a large mirror adds depth. The women wear serious but unreadable expressions, and the clothing is well displayed. Although the image has similarities with Turbeville's photographs of the Paris ready-to-wear collections for *Vogue* from the same year (see fig. 17), by the time Heiser produced the photograph for Giovanni de Moura in 1975, he was building an independent career.[20]

That year, Heiser became a contributing photographer for the *SoHo Weekly News*, a hip free paper admired for its coverage of the emerging downtown scene. Founded in 1973, the *SoHo Weekly News* was dedicated to the art, music, and business community of the neighborhood. The editors hired talented photographers, including the photo editor Allan Tannenbaum, the East Village artist-provocateur Jimmy de Sana, and the

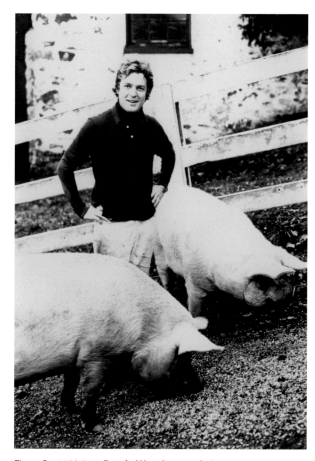

Fig. 6. Scott Heiser, **Jamie Wyeth,** 1974. Gelatin silver print, 10 × 8 inches. Brandywine River Museum Library, Chadds Ford, Pennsylvania.

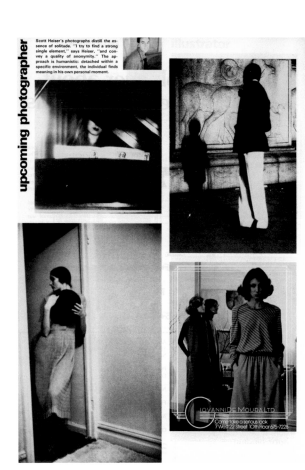

Scott Heiser's photographs distill the essence of solitude. "I try to find a strong single element," says Heiser, "and convey a quality of anonymity." The approach is humanistic: detached within a specific environment, the individual finds meaning in his own personal moment.

Fig. 7. **"Upcoming Photographer: Scott Heiser,"** in *Art Direction*, March 1976, p. 88. Printed matter. Helen Farr Sloan Library, Delaware Art Museum.

crusading documentarian Donna Ferrato. Robert Mapplethorpe made portraits for the *SoHo Weekly News,* and Robert Alexander documented dance. The style editor Annie Flanders chronicled fashion and nightlife and brought in Bill Cunningham, later known for his "On the Street" column in the *New York Times,* to provide fashion reports. His practice—snapping photographs of what people were actually wearing on the streets of New York—presented a reconceptualization of fashion reporting. When Flanders left the magazine in 1979, Kim Hastreiter, a young artist who worked in a boutique owned in part by Betsey Johnson, joined the staff as style editor, on Cunningham's recommendation, covering the fascinating collaborations between artists, designers, and musicians launched at underground venues like the Mudd Club and Club 57. On the staff of the *SoHo Weekly News,* Heiser found a group of idealistic young artists, writers, and photographers at a publication once described as an "encyclopedia of the Seventies."[21]

About Faces: Portrait Photography

For *SoHo Weekly News* and *Interview,* which became another regular source of work in the second half of the 1970s, Heiser produced portraits of artists, actors, and musicians. For *Interview* he photographed a fascinating cross section of popular and high culture, including the French actor Gérard Depardieu (1977), the architect Rem Koolhaas (February 1979), the painter Donald Sultan (March 1983), and the fashion and music impresario Malcolm McLaren (June 1983). A sensitive portrait of the blues singer Alberta Hunter, which was reproduced several times, attracted other publications like *New York Rocker,* and Heiser photographed the singer Marianne Faithfull, the writer Richard Price, the conceptual artist Robert Wilson, Andy Warhol, and Deborah Turbeville for various magazines. His subjects presented, as Hagen noted in 1983, a "rarified" selection of celebrities, reflecting the alternative cultural narrative presented by the publications that were his primary employers.[22]

Years later, Heiser acknowledged the influence of Cecil Beaton on his early celebrity portraits: "I started out doing portraits, being inspired by Cecil Beaton, all that artificiality," he explained.[23] Heiser knew Beaton through the vintage periodicals featured in Merkin's classroom, as well as from contemporary books, magazines, films, and exhibitions. Famous for his celebrity portraits, Beaton had been honored with a massive retrospective, *600 Faces,* at the Museum of the City of New York in 1969. Beaton was known for creating elaborate backdrops and entire sets to reflect upon his celebrated subjects. Heiser rarely had the time or budget for such sumptuous arrangements, but he worked effectively with the elements on hand to create dramatic portraits of famous faces.

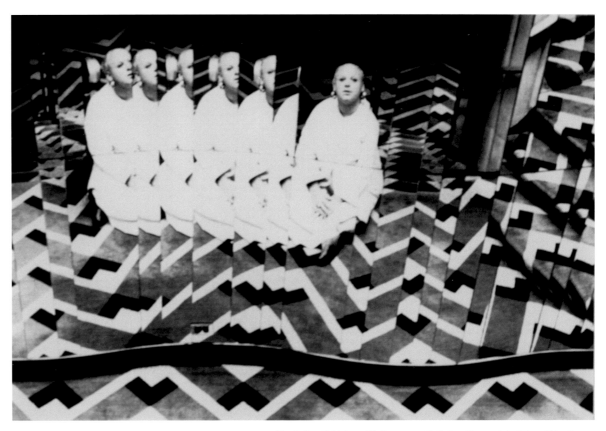

Fig. 8. Scott Heiser, **Divine,** 1975. Gelatin silver print, 6⅜ × 9½ inches. Estate of the Artist.

A sensitive portrait of the actor Harris Glenn Milstead, famous as the drag queen Divine, seems particularly deliberate and Beatonesque (fig. 8). The subject sits on an aggressively patterned floor, in front of a beveled mirror, producing a dizzying multiple image. His head is bare and he is dressed in a simple white garment, though he wears makeup and large earrings; he is only half in character. Divine's outrageous persona is implied through the funhouse setting but denied in Milstead's calm expression and underwhelming attire, reminding the viewer that Divine was a part played by an actor.

For his picture of the fashion and music impresario Malcolm McLaren, Heiser used the decor and darkness of the New York nightclub Roxy NYC to frame the musician (fig. 9). McLaren's spotlit and behatted head emerges from an obscure background, and the floral-patterned fabric that surrounds him—blackened by Heiser in the darkroom—becomes a menacing field of vines. Already famous for introducing punk style to London with his girlfriend Vivienne Westwood and for masterminding the Sex Pistols, McLaren materializes to present his next project like a ringmaster welcoming the audience. His jacket, with its distinctively

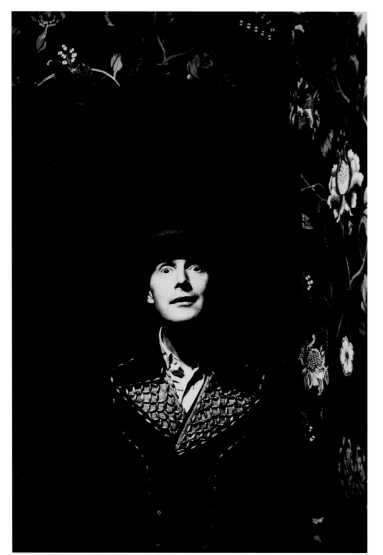

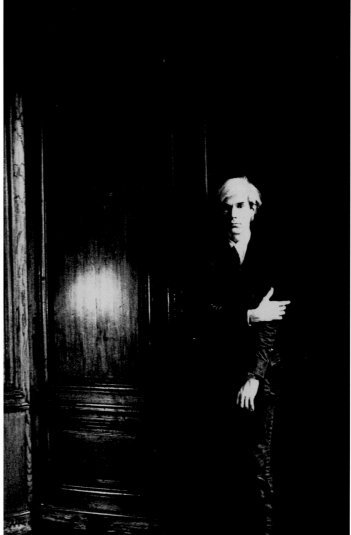

Fig. 9. Scott Heiser, **Malcolm McLaren at the Roxy, New York,** 1983. Gelatin silver print, 13 × 8⅝ inches. Estate of the Artist.

Fig. 10. Scott Heiser, **Andy Warhol,** c. 1981. Gelatin silver print, 9 × 6 inches. Estate of the Artist.

embroidered lapels, is from the Buffalo collection he designed with Westwood and released in conjunction with his groundbreaking hip-hop single "Buffalo Gals," which he was promoting in New York. Covering an entire seventeen-by-eleven-inch page, Heiser's portrait accompanied a lively conversation between McLaren and the magazine's music writer, Glenn O'Brien. It was an over-the-top presentation worthy of McLaren's reputation as a cultural provocateur.

Another outsize personality, Andy Warhol appears composed and in character in a series of photographs by Heiser (fig. 10). Wearing his trademark navy blazer and jeans, Warhol stands against a paneled wall, one arm held protectively across his chest. This is an official portrait—flattering and respectful of its subject—in contrast to Warhol's experiments with Christopher Makos from about the same time, in which the

artist appeared in a similar shirt and tie with drag makeup and a platinum blonde wig. Also unlike Warhol's Polaroid, Heiser's version was expertly printed. In the black-and-white print, Warhol's bright white wig and pale face are echoed in the glare (from a spotlight or a flashbulb) on the wooden wall beside him, which balances the composition. When Heiser's photographs of Warhol were reproduced in magazines, this glare was eliminated, but the photographer retained it in the print he exhibited.[24] Heiser had an affinity for such reflections and the spotlights that made them, which would appear repeatedly in his photographs of fashion shows and circuses from around the same time. The Warhol portrait dates from around 1981, when Heiser was raising his profile at Warhol's magazine *Interview.*

On the Runway: Fashion Photography, 1978–1987
By 1975, Heiser's close friend from RISD, Marc Balet, was working as the art director for *Interview,* and in 1978 he first published Heiser's photographs of the seasonal fashion shows in the magazine. Heiser created a unique vision of the runways that contributed to the edgy aesthetic of *Interview* in the 1970s and early 1980s. Founded by Warhol in 1969, *Interview* focused on entertainment, fashion, and culture. Especially on its covers, the magazine reflected Warhol's fascination with celebrity, although it also promoted an alternative roster of popular culture, introducing emerging and underappreciated talents in music, film, and fashion. In its profiles and interviews, *Interview* was attuned to "what's next." Under Balet, the magazine developed a strong graphic identity, in part by hiring talented, up-and-coming photographers like Robert Mapplethorpe, Bruce Weber, and David LaChapelle.

Influenced by film, as Stephen Petersen explains in this catalogue, for *Interview,* Heiser created photographic essays that focused on "motion and odd composition."[25] Positioned on the side of the runway, using available light, Heiser captured the models and the clothing in action. The resulting photographs were grainy, wildly cropped, and nearly abstract. His photographs might highlight one aspect of a particular design: the sheen and seaming of a Claude Montana cocoon coat (plate 17); the quilting on a Michael Vollbracht jacket (plate 3); and, often, the dramatic silhouette created by the clothing (plates 2 and 16). Heiser's extreme cropping and unexpected angles brought the designs to life in unexpected ways. As Glenn O'Brien noted, "sometimes details emerged, but the clothes were always alive with motion."[26] Selling clothing was never the focus for Heiser or for *Interview.*

Instead, Heiser's pictures gave *Interview*'s readers an insider's glimpse of live fashion shows in Paris, Milan, and New York. In photographs of the New York shows from 1980, Heiser's blurring and graininess

conveyed the speed of the moving models (plates 4 through 6). His per-spective, below and to the side of the catwalk, mimicked that of the spec-tators, and his cropping emphasized incidental elements like ceilings and the edges of sets. Spotlights and shadows became integral parts of his compositions. Attention was lavished on outlandish glasses, imprac-tical hats, and essentially unwearable elements of the collections—items that would only be seen at the fashion shows (plates 15 and 20). Heiser's photographs did not present the clothing in isolation, but as part of a theatrical performance, giving *Interview*'s audience front-row access to a cultural event. If they wanted to see the clothing, readers could go to *Vogue, W,* or *Women's Wear Daily*; Heiser brought them the "ethos" of the fashion show "in all its weird splendor."[27] This suited *Interview*'s innova-tive sensibility and Heiser's artistic integrity. "It wasn't until *Interview* assigned me the job of photographing the collections that I was actually able to take photos strictly as photos," explained the photographer.[28]

Heiser's runway coverage appeared in multipage spreads each sea-son in *Interview.* His images were rarely cropped, and he was credited thoroughly, and these visual essays garnered him the most attention of his career. In 1979, Heiser was interviewed on the first episode of War-hol's cable television program *Fashion,* where he appeared with the established photographer Arthur Elgort. A regular contributor to *Vogue,* Elgort brought a snapshot aesthetic to fashion photography in the early seventies, often shooting on city streets. With Heiser, he shared an inter-est in movement and natural light, though Elgort produced more tradi-tional fashion pictures, in which the clothing and the models are easily recognized. Heiser understood that his project was different, explaining that although he came to New York to be a fashion photographer, his interests shifted: "It wasn't until I actually worked for the two fashion photographers that I decided that it was all right, but it wasn't all that I wanted to do."[29]

In the early eighties, Heiser's runway photographs continued to attract attention. In 1982, Heiser was profiled in the mainstream monthly *Amer-ican Photographer* and the French photography magazine *Zoom.* Both articles featured portfolios of his runway photographs, while explaining that his images were not really about fashion.[30] In 1985, he was selected for a solo exhibition organized by the French Cultural Services, and a group of his runway photographs toured the United States for over two years under their auspices.

Building his reputation as a photographer of fashion, Heiser received more commercial work: he photographed full-page advertisements for Barney's and Tamotsu, and the New York boutique Diane B. used a series of his images from a Kansai Yamamoto show for promotion.[31] However, his abstract photographs functioned better as journalism or

art than as advertising, and he was not particularly interested in making typical fashion photographs. On assignment Heiser eschewed the usual retinue of assistants and banks of strobe lights. According to Balet, who arranged Heiser's commission from Barney's, his friend frequently brought only a single light on a shoot, and he presented clients with a limited selection of prints.[32] Working for *Interview* was high profile and artistically rewarding, but not lucrative. Unwilling to cater to the demands of mainstream fashion photography, Heiser continued to produce portraits and take on mundane assignments like photographing accessories and perfume bottles, as he increasingly turned his camera on other staged spectacles.

Under the Big Top: Circus

In an artist statement composed in the mid-eighties, Heiser described his approach to fashion photography in language that reflects his growing interest in a wider range of public events:

> I photograph fashion shows as performances; figures in motion within a specific space. . . . In France, the fashion collections are spoken of as a cultural event, as I believe they are. Spectators witness processions of ideas, many of which will never be seen again.[33]

Visiting circuses and other performances, especially when he was in Europe to photograph the runway shows, Heiser turned his trained eye from fashion models to acrobats, animals, and clowns. The highly produced fantasy world of the circus had much in common with the fashion runway, and Heiser employed similar methods to capture its beauty and strangeness. He focused on the moments between acts, and his camera recorded interesting patterns and isolated details.

Heiser was particularly interested in one-ring circuses, which allowed visitors to witness performances at close range. (Unlike at the fashion shows, where he carried a press pass, Heiser sat in the audience at the circus.) Traditional in Europe, this model was being revived in the 1970s; the most famous American example was the Big Apple Circus, founded in 1977 and resident in New York each winter, where Heiser made some of his most compelling compositions. One-ring circuses allow the audience to witness the interstitial moments between acts, and the intimate space facilitated Heiser's unsettling close-up images.

Heiser's chronicle of the circus, a self-guided endeavor that grew out of his own interests, was one of many documentary projects undertaken by photographers in the 1970s and 1980s. Many, like Heiser, balanced commercial and personal work. In 1967, John Szarkowski described the situation in the wall text for his landmark exhibition *New Documents* at the Museum of Modern Art, New York:

It can be reported without prejudice that many of today's best photographers are fundamentally bored with the mass media and do not view it as a creative opportunity. Even well-established and prospering photographers of talent, artists well beyond the first flush of youth, have tacitly accepted a double standard for their own work; their livelihoods are made according to the standards set by magazines and agencies; their serious work is done on weekends and between assignments, in the hope of producing an exhibition, or a small book, or perhaps only a personal file that someone, someday, will look at openly and slowly and with pleasure, without wondering how the picture might be made more "effective" by tighter cropping and the addition of a good caption.[34]

In his text, Szarkowski was referring to the three young photographers, Diane Arbus, Lee Friedlander, and Garry Winogrand, who were the subject of the exhibition. Heiser was a particular fan of Arbus, whose published projects included fashion photographs for the *New York Times* and photographic essays for *Esquire*. Arbus had come to RISD during Heiser's senior year, and he had an interview with her scheduled just before she killed herself in 1971. In the 1960s, Arbus balanced commercial and personal interests while crafting a distinctive style, as Heiser would a decade later. Szarkowski described this new approach to documentary photography:

In the past decade this new generation of photographers has redirected the technique and aesthetic of documentary photography to more personal ends. Their aim has been not to reform life but to know it. Their work betrays a sympathy—almost an affection—for the imperfections and the frailties of society. They like the real world, in spite of its terrors, as the source of all wonder and fascination and value—no less precious for being irrational.[35]

A generation younger, Heiser was fortunate that *Interview* provided a venue (and some support) for his fashion photographs, but his circus pictures would be produced without a commission.

In practice, Winogrand's work provides strong parallels to Heiser's approach. Winogrand's self-directed documentary projects included *The Animals*, which featured humans and animals interacting at zoos, and his famous book of street photographs, *Women Are Beautiful*.[36] Like some of Heiser's best photographs, Winogrand's photographs were generally candid shots, and his work thrived on clever juxtapositions of formal and narrative elements (fig. 11). Both photographers were able to craft personal visions within public spaces; in *Public Relations* (1977),

Winograd presented his subversive perspective on press conferences, political rallies, and museum parties.[37]

In the wake of *New Documents*, in the seventies and early eighties, many more photographers took on personal documentary projects, often focused on particular subcultures. Some of these eventually appeared as books. Neal Slavin photographed groups—from hunting clubs to female wrestlers—and Susan Meiselas documented burlesque dancers at traveling carnivals.[38] Within Heiser's circle, his friend Herman Costa worked with the writer Claire Connors to produce photo-booth pictures accompanied by interviews of the denizens of Times Square. At the circus, Heiser produced his first large body of documentary work independent of his magazine assignments. Though never gathered in a single volume, Heiser's study of the circus presented a discrete documentary project in the spirit of the time.

In the circus pictures, Heiser consistently featured the apparatus that makes the performance possible. Ropes, lights, nets, and scaffolds are important elements in his circus pictures, sharing equal space with the performers. In Heiser's hands, a stagehand holding a rope near an

Fig. 11. Garry Winogrand, **New York,** 1963, from *The Animals* (1969). Gelatin silver print, 11 × 14 inches. © The Estate of Garry Winogrand, courtesy Fraenkel Gallery, San Francisco, California.

Fig. 12. Scott Heiser, **Cirque d'hiver Bouglione, Paris,** 1982. Gelatin silver print, 5¼ × 7¾ inches. Estate of the Artist.

empty floor mat becomes a haunting and unforgettable sight (plate 38). Zebras huddle in the upper right corner of an image, their stripes echoed in a web of rigging that occupies the left third of the image (plate 33). In *Upside Down Girls, New York,* two performers—one just slightly out of alignment—are crisscrossed with ropes, creating a linear overlay that highlights the imperfect geometry of their poses (plate 28).

Time and again, Heiser's cropping denies the viewer the opportunity to see an entire figure or the culmination of a routine. Performers are headless, or represented only by their heads. In a photograph from the Big Apple Circus, a bikini-clad woman hangs on to an elephant; the frame cuts off the elephant's body and the woman's head (plate 31). Two clowns look over their shoulders, but the object of their interest lies outside the frame (plate 37). A performer dressed as Pierrot holds a figure aloft, balanced on one foot, but Heiser cuts the upper figure off at the knee (plate 30). Heiser was uninterested in "climaxes of performances."[39]

Heiser's circus photographs first appeared in the British journal *Creative Camera* in 1982 in an issue headlined by Man Ray and Lee Miller.[40] In his

Fig. 13. Man Ray, **Érotique Voilée,** 1933. Gelatin silver print, 11½ × 9 inches. Collection of Michael Mattis and Judith Hochberg. © 2013 Man Ray Trust/Artists Rights Society (ARS), NY/ADAGP, Paris.

portfolio of seven half-page plates, a trapeze artist is headless (fig. 12), a horse looks spooked (plate 29), and ropes go nowhere. The isolated performers seem vaguely endangered and the atmosphere is ominous. Dense black backgrounds and dramatic cropping enhance the sense of the uncanny. Heiser's vision of the circus is both familiar and foreign, and his photographs received an extra psychological charge in *Creative Camera*, placed in proximity to Man Ray's surrealist masterpieces, *Érotique Voilée* (fig. 13) and *La Prière*.

With the groundbreaking exhibition *Photographic Surrealism* in 1980 and the high-profile *L'Amour Fou: Photography and Surrealism* in 1985, in the 1980s surrealism became a popular filter for interpreting photographs by contemporary artists.[41] With their dramatic shadows and fragmented figures, Heiser's photographs of fashion shows and circuses fit seamlessly into this narrative. In 1987, four of his photographs were featured in Richard Martin's book *Fashion and Surrealism*, and in 1989, when Heiser had a solo show at New York's Paula Allen Gallery, a reviewer placed Heiser under an umbrella of "A New Surrealism."[42]

At the Garden: Staged Spectacles

Photographing the circus quickly led Heiser to other public performances. In 1981, *Interview* published his photographs of a rehearsal for the Miss Universe pageant, and the following year he chronicled the Westminster Kennel Club Dog Show for the first time.[43] Like his images of fashion shows and the circus, his glimpses of the dog show are blurry, grainy, and tinged with humor. The massive furry face of a chow chow fills most of one frame (fig. 14), while two poodles appear decapitated (plate 44). A greyhound is handled exactly like a fashion model or acrobat—set off against a plain background, frozen and headless (plate 56). In a masterful juxtaposition, a handler, seen only as a leg with an ankle brace, leads a bull terrier (plate 48).

Heiser's photographs from the Miss Universe pageant hint at a new direction. The magazine montage of Miss Universe includes a clever phalanx of legs across the bottom edge of the page, as well as individual images of four contestants (none of them the winner) (fig. 15). These women, one of whom catches the photographer at his task, appear as distinctive individuals, whose personalities penetrate the designs of the photographer and art director. At the pageant, Heiser captured both

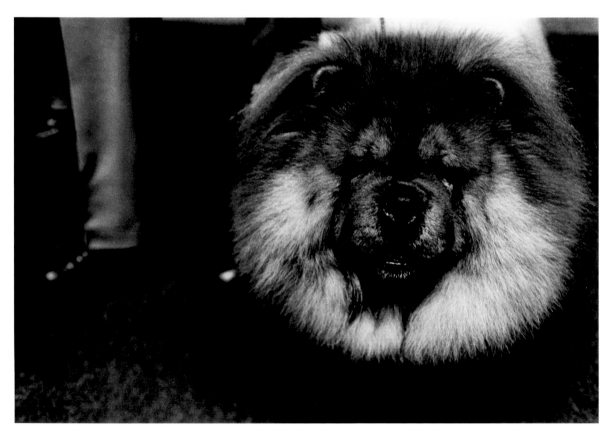

14. Scott Heiser, **Chow Chow, Westminster Kennel Club Dog Show,** 1982. Gelatin silver print, 8 × 12 inches. Estate of the Artist.

pattern and particularity, introducing greater emotional warmth into his pictures.

By the late 1980s, Heiser's interest was pointedly psychological. To the art critic David Hirsh, Heiser explained his fascination with public performance: "These come out of being shy and unpopular as a kid and finding it unimaginable and fascinating—it still is—that anybody would have the guts to stand up in public and subject themselves to possible ridicule." Amateur and professional performers captivated him; his subjects ranged from the Rockettes to dance school recitals. Finding his own brand of runway photography "too easy," Heiser increasingly focused on other events.[44] And despite the formalism that continued to mark many of his images, Heiser described himself as "working his way out of, 'Is it pretty? Is it well designed?'"[45]

For the rest of his life, Heiser's curiosity about performances was almost unbounded. He began to haunt Madison Square Garden and the plaza outside the World Trade Center, which frequently served as an outdoor stage for international performance groups. Heiser visited athletic events, air shows, parades, mass weddings, and dance competitions— any place where groups of people gathered in public for an organized activity. For some of these events he used his press credentials, but for most, he bought a ticket like the rest of the audience. Trips to the Ice Capades and dance competitions resulted in eerie images from the stands (plates 52 and 45).

Some of Heiser's event pictures found their way into *Interview*, but many more were reserved for a new publication, *Paper*. Started by Kim Hastreiter and David Hershkovits, former editors of the *SoHo Weekly News*, *Paper* could be described (as Hastreiter has been) as "Pre-*Vogue*" in its orientation toward emerging talent.[46] Concerned with style and the arts in New York, and especially in SoHo, when it was founded in the mid-eighties, *Paper* had a distinctly downtown vibe. The editors hired their creative friends, including Heiser, and encouraged them to pursue their own interests. Heiser scooped up free tickets and press passes to attend various activities around New York. He produced images and composed captions for a regular column called "Room for a View," then "Room for Another View," and later "Another Clue."

Heiser's monthly contribution included a photograph with a brief and generally humorous caption. In honor of the reinstallation of the gallery of arms and armor at the Metropolitan Museum of Art, Heiser photographed a man in a yarmulke standing in front of a suit of armor (plate 55). The caption reads: "Helmet: a protective covering for the head—*Webster's Ninth* and the Metropolitan Museum of Art."[47] Not assigned, these images of jugglers, dancers, and Chinese acrobats reflected Heiser's passions and point of view. As he traveled around the city and beyond

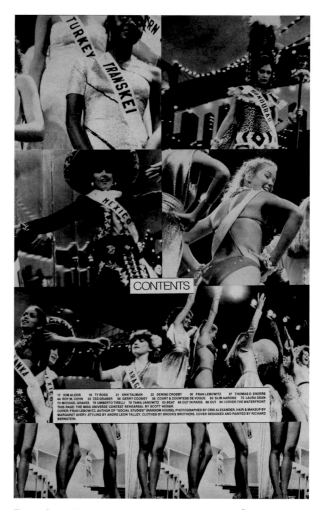

Fig. 15. Scott Heiser and Marc Balet, **Contents,** in *Interview*, September 1981. Printed matter. Scott Heiser papers, Delaware Art Museum.

capturing performers and athletes for his own art, he also made images for his column in *Paper*. Swedish gymnasts produce a repetitive pattern as they perform on the plaza at the World Trade Center, and synchronized swimmers appear at the Manhattan Plaza Health Club (plates 49 and 51).[48] In both cases, Heiser sent one version to *Paper* while printing alternate views for himself, a practice he followed since his days working for *Interview*.

Even on assignment, Heiser's photographs were always interesting and a little off-center. Hastreiter liked to send him to photograph banal subjects, because he came back with clever compositions. Visiting a museum exhibition dedicated to Charles James, Heiser used his eye for texture and lighting to bring dimension to static clothing draped on dress forms.[49] Hastreiter and Mickey Boardman summed up Heiser's approach with the following example: sent to take a picture of an event at a miniature golf course, "he came back and the picture was just the hole."[50]

Parades resulted in some of his most poignant images. Representatives from the American Legion march behind a huge flag, made transparent by the sun (plate 50). On the periphery of the Miss America pageant, a boy and a girl look bored (plate 54). Heiser photographed many sporting events, from boxing to bodybuilding to Eastern European gymnastic competitions called *Sokol Slets* (plates 46, 57, and 59). Heiser's event photographs were featured in exhibitions at the Paula Allen Gallery in 1989 and at the Midtown Y Photography Gallery in 1991–1992 and in a portfolio in *Shiny: The Magazine of the Future* in 1991.[51]

These sensitive images of youth, health, and community take on added poignancy with the realization that Heiser was gravely ill with AIDS when some of them were made. As his illness worsened, he withdrew from friends and social activities, yet continued to photograph and to plan upcoming projects. His contributions would appear in *Paper* months after his death. He also began to think about his legacy, offering several works to the Delaware Art Museum, and the donation of nine fashion photographs was completed by his mother after his death in 1993. One of many artists, photographers, and designers lost to AIDS in the eighties and early nineties, Heiser was included in a memorial in the *New Yorker* in 1994.[52] Laurie Rosenwald printed his name on one of two hundred empty seats representing individuals in the fashion industry lost to the disease. Heiser was forty-four when he died. A published photographer for more than twenty years, he had brought a distinct perspective to the fashion shows, circuses, and public spectacles that captured his attention. Graphically strong and psychologically resonant, Heiser's best photographs preserve performances both extraordinary and commonplace in timeless, captivating images.

Notes

1. Charles Hagen, "'Faces Photographed: Contemporary Camera Images,' Grey Art Gallery," [Review], *Artforum* 21, no. 6 (February 1983): 78.

2. Scott Heiser, "Runway: New York," *Interview* 8, no. 12 (December 1978): 76.

3. A color photograph of the jacket appeared in "Fashion: The New York Collections: One-of-a-Kinds," *Vogue* 169 (September 1, 1979): 470.

4. Hagen, "Faces Photographed," 78.

5. Mary G. Heiser, conversation with the author, May 31, 2011.

6. Kate Irvin and Laurie Brewer, *Artist/Rebel/Dandy: Men of Fashion* (New Haven: Yale University Press and RISD, 2013), 13.

7. Anonymous, email to the author, May 21, 2012.

8. Nancy Hall, interview with the author, May 12, 2012.

9. "Gallery 35: Scott Heiser," *35mm Photography* (Spring 1974): 76, 78.

10. Anonymous, email to the author, May 21, 2012.

11. Hall, interview with the author.

12. Deborah Turbeville, interview with the author, May 23, 2012.

13. Deborah Turbeville, *Deborah Turbeville: The Fashion Pictures* (New York: Rizzoli, 2011), 60.

14. The Clevedon pictures appeared in *Nova* in December 1973, and some are reproduced in *Deborah Turbeville*, 20–25. The bathhouse pictures appeared in "There's More to a Bathing Suit than Meets the Eye," *Vogue* 165 (May 1, 1975): 124–33. Turbeville recalls the reception they received in *Deborah Turbeville*, 57.

15. Turbeville, interview with the author.

16. Heiser kept a running list of places that his work appeared as well as an account book detailing payments for his photographs, his darkroom work, and his work as an assistant. Scott Heiser Papers, box 1, Delaware Art Museum.

17. Scott Heiser, "Down on the Farm with Jamie Wyeth," *Interview* 4, no. 2 (February 1974): 12–14.

18. Wyeth ordered copies, and Heiser's portrait would appear later in *An American Vision: Three Generations of Wyeth Art* (Chadds Ford, PA: Brandywine River Museum, 1987), 69.

19. "Upcoming Photographer: Scott Heiser," *Art Direction* 27 (March 1976): 88.

20. On his résumé, Heiser listed 1973–75 as the years he worked for Turbeville, but his ledger records payments from Turbeville through 1977, and she thanked him as an assistant in her book *Wallflower*, published in 1978. Heiser Papers, box 1.

21. Allan Tannenbaum, *New York in the 70s* (New York: Overlook Duckworth, 2009), 7.

22. Hagen, "Faces Photographed," 78.

23. Heiser quoted in David Hirsh, "A New Surrealism," *New York Native*, no. 310 (March 27, 1989): 21.

24. A color version appeared in Diana Loevy and Veronica Visser, "From Campbell's Soup to Cable," *Home Video*, November 1981; and Catherine Bush, et al., *All America: The Catalogue of Everything American* (New York: Quarto Marketing, 1987).

25. "Flash! The Lost Tribe of Seventh Avenue," *American Photographer* 8, no. 5 (May 1982): 89.

26. Glenn O'Brien, "Re-Make/Re-Model: Jessica Craig-Martin," *Frieze*, no. 60 (June–August 2001), http://www.frieze.com/issue/article/re_make_re_model/.

27. "Flash! The Lost Tribe," 89.

28. Artist statement, c. 1984, Heiser Papers, box 2.

29. *Fashion*, "Models and Photographers" (Warhol TV), Take 10 Manhattan Cable TV, 1979. Collection of the Paley Center for Media, New York, NY.

30. "Flash! The Lost Tribe," 89. François Caillat, "Scott Heiser," *Zoom* 92 (1982): 90. Translated by Maeve Coudrelle.

31. Advertisements for Barney's, New York, with Heiser's photographs appeared in *Interview* 11, no. 4 (April 1981) and Interview 11, no. 5 (May 1981). A tear sheet with a similar advertisement in the *New York Times* is in Heiser Papers, box 8. Tear sheets of advertisements s for Tamotsu and Diane B. with Heiser images are in Heiser Papers, box 8.

32. Marc Balet, interview with the author, March 26, 2012.

33. Scott Heiser, untitled statement, c. 1985, draft letter to Hisami [Kuroiwa], Heiser Papers, box 2.

34. Quoted in *Diane Arbus: Magazine Work* (New York: Aperture, 1984), 165–66.

35. John Szarkowski, "Wall Label," reproduced in Museum of Modern Art, "Press Release: New Documents," February 28, 1967. See http://www.moma.org/docs/press_archives/3860/releases/MOMA_1967_Jan-June_0034_21.pdf?2010.

36. Garry Winogrand, *The Animals* (New York: Museum of Modern Art, 1969), and *Women Are Beautiful* (New York: Farrar, Straus and Giroux, 1975).

37. Garry Winogrand, *Public Relations* (New York: Museum of Modern Art, 1977).

38. Neal Slavin, *When Two or More Are Gathered Together* (New York: Farrar, Straus and Giroux, 1976); Susan Meiselas, *Carnival Strippers* (New York: Farrar, Straus and Giroux, 1976).

39. Scott Heiser, untitled statement, c. 1985, draft letter to Hisami [Kuroiwa].

40. "Scott Heiser," *Creative Camera* no. 216 (December 1982): 770–75.

41. In 1980 the New Gallery of Contemporary Art, Cleveland, Ohio, organized the exhibition *Photographic Surrealism,* with a catalogue by Nancy Hall-Duncan, which traveled to the Brooklyn Museum. In 1985, the traveling exhibition *L'Amour Fou: Photography and Surrealism* was organized by Rosalind Krauss and Jane Livingston, occasioning much discussion of the topic. Richard Martin's 1987 publication, related to an exhibition at the Fashion Institute of Technology the previous year, reproduced many surrealist photographs related to fashion.

42. Richard Martin, *Fashion and Surrealism* (New York: Rizzoli; Fashion Institute of Technology, 1987), title page, 30, 55, and 189.

43. Scott Cohen, "Top Dogs," *Interview* 12, no. 3 (March 1982): 62–63. Miss Universe: *Interview* 11, no. 9 (September 1981): contents page.

44. Herman Costa, interview with the author, April 18, 2012.

45. Heiser quoted in Hirsh, "A New Surrealism," 21.

46. Isaac Mizrahi quoted in Dana Goodyear, "The Enthusiast: Kim Hastreiter's Downtown," *New Yorker* 83, no. 28 (September 24, 2007): 114.

47. Scott Heiser, "Another Clue," *Paper,* March 1993, 6.

48. Scott Heiser, "Room for Another View," *Paper,* September 1988, 22. Scott Heiser, "Room for Another View," *Paper,* June 1989, 18.

49. Heiser's photographs appeared in Gene Krell, "King James," *Paper,* April 1993, 32–35.

50. Kim Hastreiter, interview with the author, April 25, 2012.

51. "Portfolio: Scott Heiser," *Shiny: The Magazine of the Future* no. 6 (Spring/Summer 1991): 95–109.

52. Laurie Rosenwald, "In Memoriam," *New Yorker,* November 7, 1994, 222–23.

Not a Journalist

STEPHEN PETERSEN

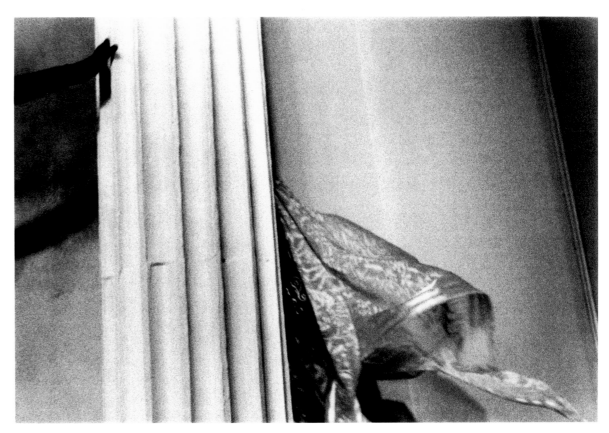

Fig. 16. Scott Heiser, **Thierry Mugler, Paris,** 1981. Gelatin silver print, 5¼ × 7¾ inches. Estate of the Artist.

A **1981 photograph by Scott Heiser** shows an enigmatic scene (fig. 16). From behind a fluted column, which dominates the image, comes a flutter of silky fabric, trailing in the wake of a figure who has disappeared from view. To the left, what appears to be a gloved arm extends into the frame, touching the column. The arm's shadow falls on the wall behind the column. The angle of the photograph is slightly aslant, and looking up from below. The picture is as notable for what we do not see as for what we do. Most of the image consists of the column and empty space. Present merely by implication, the two figures, one obscured and the other off-frame, are disconnected, linked only by the picture's strange choreography. It is like a random frame from a movie, a passing shot made as the camera moves from one significant action to another. Yet this ever-so-fleeting moment is frozen into an indelible image.

The photograph appeared in print in *Interview* magazine as part of a fashion feature on 1982's Spring/Summer Paris collections, along with a label identifying the designer, Thierry Mugler.[1] As an example of runway photography, however, it runs perversely counter to the conventions of fashion journalism. Despite the implied presence of two models, we do not see either figure, nor, apart from the scarf and the glove, do we see

any of the clothing they wear. Rather than giving us information, Heiser seems to withhold it. He deviates from standard runway photography by, as he put it in an artist's statement written about 1985, "abstracting the action as much as possible." His professed interest was in "movement and gesture," the emphasis on performance over product. Rather than the clothes, Heiser focused on the mood of the fashion show as a creative event. He asserted adamantly that he was "not a journalist," insisting that his photographs should not be considered "documentation" and that he was not "taking pictures to be read for information."[2]

The vehemence with which he sought to distance himself from photojournalism, with its claim to reportage and its goal of conveying information through pictures, is no less striking when we consider that Heiser operated, on a superficial level at least, very much like a photojournalist. He typically photographed public events, using a 35mm camera and black-and-white film, often working alongside journalistic photographers, and he published the resulting images in the periodical press. There, however, the similarities end. Heiser's work may have used the occasion of public performance as its basis, and the venue of the picture press as its outlet, but it remained a highly personal endeavor.

After growing up in a middle-class suburb of Wilmington, Delaware, Heiser went on to attend the Rhode Island School of Design in Providence starting in 1967. While at RISD he changed from graphic design to the photography department, then under the leadership of Harry Callahan. A celebrated teacher, Callahan had designed an innovative photography program at the Illinois Institute of Design in Chicago before coming to RISD in 1961. In his work and in his teaching, Callahan approached the medium of photography as an ongoing exploration, an endless succession of problems to be investigated by means of camera and film. His curriculum as summarized in 1969, at about the time Heiser joined the program, consisted of a sequence of steps that simultaneously gave the student fluency in the technical possibilities of photography and encouraged the student to "explore his own capacity for creative manipulation of the medium and to develop individuality." One such step investigated "the possibilities of altering the appearance of the subject through changes in the camera point of view."[3] Warning against imitating his style or anyone else's, Callahan, along with others at RISD, encouraged students to find their own distinct approaches. Developing a personal viewpoint would become a guiding principle for Heiser, who was inspired by Callahan's lifelong devotion to photography as a discipline.

Moving to New York in 1971, Heiser worked as a photographic assistant while seeking to do his own professional work. His very first assignment would come from Andy Warhol's still-new *Interview* magazine in 1972 (a picture of a city cab driver accompanying an anonymous interview

between a cabdriver and a "fare" discussing contemporary politics).[4] By the mid-1980s, Heiser's work had appeared in some fifty different publications—ranging from *Mademoiselle* to *Ms.*, from the *New York Times* to the *Village Voice*, from *Crawdaddy* to *Opera News*—affording him a livelihood as well as bringing his images before millions of readers. But the work for which he became best known was the fashion photography he did for *Interview*, where hundreds of Heiser's runway images appeared in innovative layouts over the course of a decade, from 1978 to 1987.

Founded by Andy Warhol in 1969, *Interview* (originally called *Inter/ VIEW*) began as a "monthly film journal" and quickly became a wide-ranging magazine covering celebrities, fashion, and culture, offering an independent alternative to the mainstream illustrated press. Over the course of the 1970s it became thicker and increasingly photography-oriented, featuring the work of such names as Robert Mapplethorpe, Chris von Wangenheim, Bruce Weber, David LaChapelle, and Patrick Demarchelier.

Working as a regular contributor to *Interview* starting in the mid-1970s, Heiser was initially assigned to do portraits to accompany the magazine's interviews, before expanding to fashion coverage. His approach to portraiture was characterized by the critic Charles Hagen, on the occasion of the 1982 portrait exhibition at the Grey Art Gallery at New York University entitled *Faces Photographed: Contemporary Camera Images*, as being "based on the *japonisme* tricks of turn-of-the-century Photo-Secession pictorialism: within elongated frames, the figures are usually pushed to one side of a moodily lit scene, reflected in mirrors, or seen through sunstruck windows."[5] Like the pictorialists, Heiser employed dark and light tonalities to create enigmatic sensations and to convey emotion or "mood," an important component to his photography. But the "elongated frame" of Heiser's portrait images is in fact the frame of the uncropped 35mm negative, which is not something normally associated with the pictorialists, nor are his prints overtly manipulated as theirs often were. In the show, his portraits, many done for *Interview*, were featured among those by eighteen contemporary photographers who were stretching the definitions of portraiture in the early 1980s, among them Cindy Sherman, David Hockney, William Wegman, Peter Hujar, Nan Goldin, and Mapplethorpe.[6]

While continuing to do portraits ("All along, I have always done a mixture of various things—portraits, fashion, and photo essay," said Heiser[7]) and also run-of-the-mill commercial and editorial assignments, in 1978 Heiser began to photograph the major runway shows in New York, Paris, Milan, and elsewhere for *Interview*, a role he filled for nearly ten years. From the outset, his catwalk images were radically unlike conventional fashion reportage. In Heiser's *New York Times* obituary, headlined "Scott

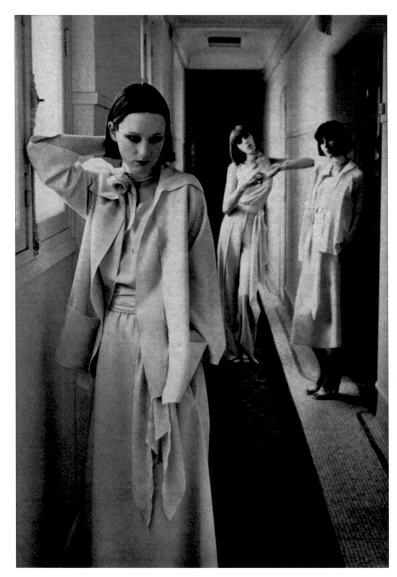

Fig. 17. Deborah Turbeville, **Karl Lagerfeld for Chloé,** in "Fashion: Paris Ready-to-Wear Preview: The New Femininity," *Vogue,* January 1975, p. 94.

Heiser, Leader and Innovator, 44, in Fashion Pictures," Randy Kennedy wrote, "His runway photos were minimalistic, often blurry and wildly cropped, sometimes showing very little of the clothing on display."[8] Yet it was precisely these "surrealistic runway fashion shots" for which Heiser became "known" and which are a key to his legacy, as he himself recognized. Nearing his death in the fall of 1993, Heiser, only forty-four years old, approached the Delaware Art Museum with a donation of his fashion photographs done for *Interview.* These were, he said, "of great importance to my career in New York."[9]

Heiser gravitated to fashion from the start. Coming to New York after RISD, he soon sought out Deborah Turbeville, who was still quite early in her career as a photographer but making a name for herself with her moody set pieces. He worked as her assistant on shoots between 1973 and 1975. According to Heiser's résumé, he also assisted in covering the Paris prêt-à-porter collections in November of 1974, presumably also for Turbeville, whose piece on the collections appeared in *Vogue* two months later.[10] Turbeville's images featured models posing on site at the historic Hôtel Lutetia, standing apart like isolated figures in an Antonioni film, illuminated by natural, ambient lighting (fig. 17). The black-and-white photographs appear to have been taken with a 35mm camera rather than the higher-definition 2¼-inch or larger formats used by most editorial fashion photographers, resulting in a grainy texture. Turbeville's approach, using simplified technical means to create an enigmatic atmosphere, quickly gained notoriety in the fashion world and beyond and would influence Heiser, who favored the 35mm camera and ambient lighting throughout his career.

Amid a boom in photography as a fine art in the 1970s, there was a widespread reassessment of fashion photography as a neglected art form and a new subject for historical study. A watershed event in this regard was the 1975 exhibition *Fashion Photography: Six Decades,* organized by Robert Littman at the Emily Lowe Gallery of the Hofstra University Museum in Hempstead, New York, and featuring the work of some twenty-five photographers whose images had appeared in the fashion press. In a small publication accompanying the exhibition, the *New York Times* photography critic Gene Thornton noted that "fashion photography is an art produced for the public. In magazine and newspaper reproduction it is seen by millions of people around the world, but nobody takes it seriously."[11] Despite or even because of their commercial intent (they are "only made to sell clothes"), fashion photographs had documentary value, offering a window into the state of culture when they

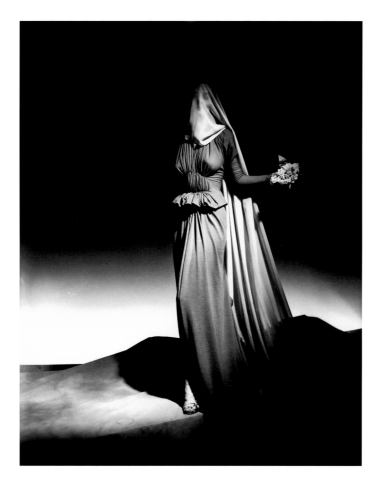

Fig. 18. George Platt Lynes, **Untitled (Madame Grès),** 1940, printed by Scott Heiser, 1975. Gelatin silver print, 9⅝ × 7⅝ inches. Scott Heiser Papers, Delaware Art Museum. © Estate of George Platt Lynes.

were produced. To exhibit fashion photographs as independent fine art, however, had little precedent at the time. They "were generally considered as ephemeral and commercial as the apparel they displayed" wrote Dorothy Seiberling in *New York* magazine, calling *Six Decades* the "first major exhibition of outstanding fashion photographs" ever to be held.[12] Owen Edwards, writing in the *Village Voice,* suggested that Littman and his staff at Hofstra were "far enough out of the cautious mainstream of photography" to embrace the heretofore ignored work done for fashion publications.[13]

Heiser's résumé shows that he was involved in preparing the groundbreaking exhibition, making exhibition prints from archival negatives "on loan from the Museum of Modern Art."[14] Several prints in Heiser's own archive are evidently seconds from this group, including a surrealistic image of a veiled woman by George Platt Lynes that was reproduced in *Newsweek* in an article on the show (fig. 18).[15] The otherworldly picture shows an imaginary landscape created in the studio featuring an ambiguously draped figure wearing a classically inspired gown created by the designer Madame Grès. Making exhibition prints of such midcentury

fashion photographs would have provided Heiser a unique education in the aesthetics of the form; the fact that he kept a half-dozen prints for himself suggests his personal investment in the project.

Photographers in the show included Baron Adolf de Meyer, said to be the first modern fashion photographer, followed by Edward Steichen, who bridged the worlds of fine-art photography and magazine fashion at the highest levels of both. Others featured in the exhibition included mid-century figures such as George Hoyningen-Huene, Louise Dahl-Wolfe, Cecil Beaton, Horst P. Horst, and Lynes; the postwar photographers Irving Penn and Richard Avedon, among others; and representatives of the newest generation, notably Turbeville, who had a prominent place at the conclusion of *Six Decades.*

Reviews of the show, such as Hilton Kramer's in the *New York Times,* entitled "The Dubious Art of Fashion Photography," evaluated the aesthetic merits of the works, generally regarding them as uneven.[16] But the reviews were consistent in praising the exhibition for turning attention to a long-neglected area of photography.

Following *Six Decades,* the second half of the 1970s would see the first great wave of fashion photography monographs and anthologies along with a number of important exhibitions. Cecil Beaton and Gail Buckland's comprehensive 1975 history of photography, *The Magic Image,* included a lengthy appendix devoted to applied photography, with sections on fashion, press, theater, and ballet photography. Beaton stated flatly, "the first artist in fashion photography was Baron de Meyer," acknowledging the overlooked artistry of fashion photography and beginning a history of the form.[17] The following year de Meyer would be the subject of a monograph published by Knopf.[18] In 1978 a deluxe illustrated book on the fashion career of Richard Avedon, *Avedon: Photographs, 1947–1977,* appeared, along with an exhibition and related catalogue from the International Center for Photography in New York devoted to the Hungarian-born photographer Martin Munkácsi, who had introduced action photography into fashion work and who as a photographer for *Harper's Bazaar* starting in the 1930s had been influential on Avedon and many others.[19] A second book on Munkácsi appeared in 1979, including a variety of stop-motion and public-event images featuring performers (both humans and animals) caught in the midst of an action.[20]

Perhaps the most suggestive publication with regard to the subsequent development of Heiser's work was a 1977 book by Penn, *Inventive Paris Clothes, 1909–1939: A Photographic Essay by Irving Penn.* Based on a Diana Vreeland exhibition of Paris fashion at the Metropolitan Museum of Art's Costume Institute entitled *The 10s, the 20s, the 30s: Inventive Clothes, 1909–1939,* the book featured evocatively lit and cropped images of mannequins wearing haute-couture dresses.[21] The

mannequins, with their limbs strangely expressive and alive, are photographed in dramatic shadow and silhouetted against empty backdrops. The notion of a "photographic essay" as a related sequence of images would become especially important for Heiser, and the seriousness of artistic intent with which Penn approached a subject previously thought frivolous or merely commercial was a sign of the wholesale reevaluation of fashion photography then taking place.

The new status of fashion photography as an art form was solidified in 1977 when the International Museum of Photography at the George Eastman House in Rochester, New York, presented a major survey in the *History of Fashion Photography*, which traveled to the Brooklyn Museum that fall. The exhibition included a lengthy section "Surrealism and Fantasy" (with a variant image of the Lynes photograph Heiser had printed for the *Six Decades* show), and it ended with a substantial segment on Turbeville, with whom Heiser had only lately worked as an assistant. An extensive book based on the exhibition was published in 1979, alongside the equally comprehensive *Vogue Book of Fashion Photography 1919–1979,* which provided a decade-by-decade overview of the most important fashion photographers.[22] Never before had fashion photography received such sustained and in-depth attention (at least outside the fashion magazines), a trend that would only continue in the 1980s.

It was at the end of 1978, amid this first explosion of interest in fashion photography as a serious art form, that Heiser published his first runway feature, in *Interview*'s December issue, covering the New York spring collections over five pages.[23] A few months later Heiser's first pictorial features on the Paris and Milan collections appeared over nine pages in the May 1979 *Interview,* beginning a succession of twice-yearly visits abroad.[24] Covering the seasonal shows in New York, Paris, Milan, and elsewhere for *Interview* gave Heiser not only a subject to explore but the freedom to explore it without interference, and ample space on the page to unroll his vision. For him it was a turning point: "But it wasn't until INTERVIEW assigned me the job of photographing the collections that I was actually able to take photos strictly as photos."[25] The leeway to "take photos strictly as photos" and to present them in sequence afforded by *Interview* would open the way for Heiser's decade-long exploration of what *American Photographer* aptly called the "far side of fashion."[26]

Heiser's initial enthusiasm for fashion photography—with its allure of visual fantasy—was tempered, however, by his professional experience in the field. Interviewed in 1979 for the first episode of Warhol's cable television program *Fashion,* Heiser said, "Originally when I came to New York I wanted to . . . ultimately, I wanted to be a fashion photographer. And it wasn't until I actually worked for the two fashion photographers, that I decided that it was all right, but it wasn't all that I wanted to do." In

addition to chafing at the artistic compromises demanded of a professional fashion photographer, he was disillusioned with the increasingly prosaic nature of mainstream fashion magazines at the time, compared with the postwar magazines epitomized by *Vogue* and *Harper's Bazaar*:

> When I was in school and I looked at magazines, my feeling about magazines was, it was a very rarified kind of existence that you were photographing, you were photographing things that probably would just appear in the magazine, that had nothing to do with real life. And of course I ate that up, because I was always interested in . . . in kind of escapist-type pictures, no matter what I did, and anything realistic I was never really interested in. And of course all that changed just because . . . the way magazines looked [has changed].

Feeling he missed out on a golden era of fashion, Heiser said he felt "it's too bad, I got to New York late."[27]

In many ways *Interview* was an exception to trends in the fashion press, offering a throwback to the magazines of the 1950s and 1960s even as it helped to define the contemporary sensibility of the dawning 1980s. In both its oversize format (it measured nearly eleven by seventeen inches) and its willingness to turn over entire pages to pictures, *Interview* was a unique venue for publishing a photographer's work. "There was nothing else like it," said Marc Balet, a good friend of Heiser's from RISD who worked as a design consultant to *Interview* and then, for nearly a decade, as the magazine's art director.[28] In charge of hiring photographers and overseeing the editorial layout, Balet was instrumental in supporting Heiser's work for the magazine. The results of their working relationship, at their best, recall the collaborations between Alexey Brodovitch, the legendary *Harper's Bazaar* art director, and the photographers he championed, among them Penn, Avedon, Henri Cartier-Bresson, Bill Brandt, Man Ray, Brassaï, Robert Frank, Hoyningen-Huene, and Dahl-Wolfe, who credited him with making her for the first time "conscious that a photograph must relate to the page."[29] Brodovitch understood the interdependence of photographer and art director, arguing that photographers should remain independent: "The photographer, if he is to maintain his integrity, must be responsible to himself. He must seek an audience which will accept his vision rather than pervert his vision to fit an audience."[30] Brodovitch also made his own photographs, including his series of dance images published as a sequence in the book *Ballet* in 1945 (Brodovitch's work both as an art director and as a photographer was featured in the readily available, generously illustrated 1972 catalogue *Alexey Brodovitch and His Influence*). His unconventional 35mm black-and-white images of ballet performances were shot in real time with existing light, resulting in strong contrast and oftentimes blurred gestures (fig. 19).

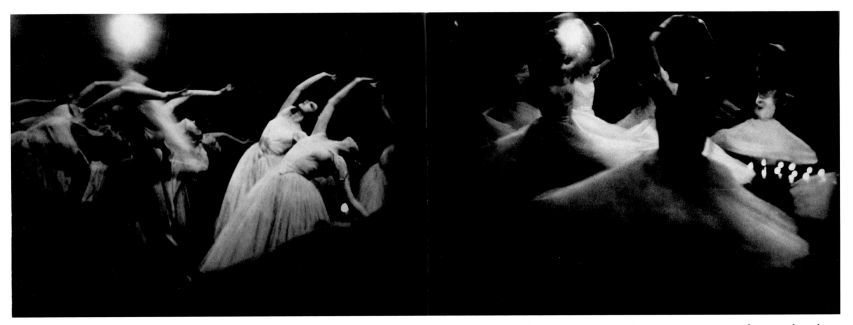

Fig. 19. Alexey Brodovitch, from **Ballet** (1945), in *Alexey Brodovitch and His Influence* (Philadelphia: Philadelphia College of Art, 1972), pp. 34–35.

As art director at *Interview,* Balet was responsible for the appearance and layout of Heiser's contributions. Warhol had ultimate approval, however, and was always enthusiastic about Heiser's work for the magazine (Heiser turned in his last runway shoot shortly after Warhol's death in 1987, and Balet left the magazine soon thereafter as well).

In general, photographers working for *Interview* had free rein to do the kind of images they wanted to and even to choose the ones that would be published. Heiser typically developed and printed his own work to his own deliberate specifications (often working in a makeshift darkroom in his small apartment), and then selected his photographs for publication. He cropped only in the camera, not in the darkroom, and said he was greatly distressed when seeing in print "a picture of mine that's been cropped beyond recognition."[31] Balet only rarely cropped Heiser's images, and indeed the format of *Interview* fortuitously echoed that of the full 35mm negative frame. The relative dimensions of the *Interview* page are just slightly longer than the 2:3 aspect ratio of the 35mm negative, allowing a full-frame image to fill the page, among many other possible layout options.

From the start, Heiser's runway features were laid out to emphasize their cinematic qualities, highlighting his use of cropping, silhouettes, and dynamic points of view. Sometimes the frames were montaged together so that abstracted light and dark shapes resulted (fig. 20); other times they were laid out around the page or across the spread. The result was an adventurous approach to the runway shows that was absolutely

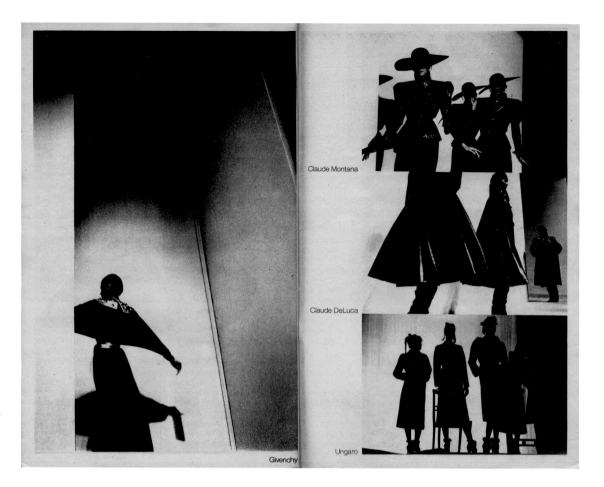

Claude Montana

Claude DeLuca

Ungaro

Givenchy

Fig. 20. Scott Heiser and Daniela Morera, **"The Collections: Paris and Milan,"** in *Interview,* May 1979, pp. 66–67. Printed Matter, Helen Farr Sloan Library, Delaware Art Museum.

unique to *Interview,* and one that would not have been possible anywhere else in the fashion press at that time. Says Balet, "We were doing things that no one else was allowed to do."[32]

In his own, canny fashion, Warhol courted haute-couture designers as advertisers in *Interview* paradoxically by refusing to play the game of reporting on their collections. Heiser and Balet, with Warhol's blessing, were able to represent the runway shows in an utterly unconventional way, typically with a single image per designer with the designer's name placed next to it. Depending on the particular photograph, the clothes themselves might or might not be illustrated with any degree of legibility, the figures were often shown in complete silhouette, and in any case the graphic nature of the overall layouts took precedence over the individual images (fig. 21).

Writing some years later, Glenn O'Brien took the occasion of an exhibition write-up to recall Heiser's runway photos, which he placed in the company of some of the most esteemed fashion work of the post-war era:

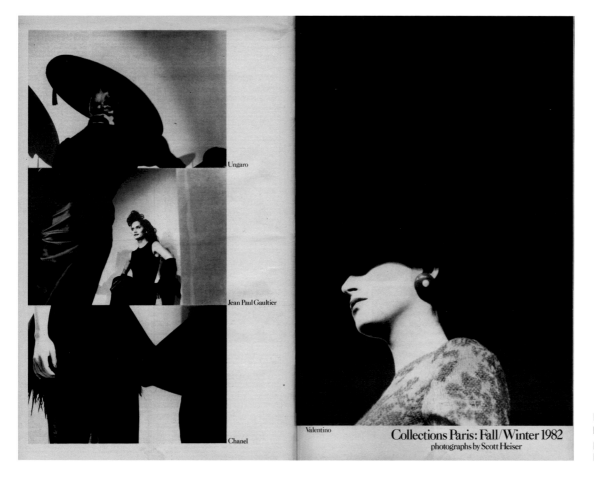

Ungaro

Jean Paul Gaultier

Chanel

Valentino

Collections Paris: Fall/Winter 1982
photographs by Scott Heiser

Fig. 21. Scott Heiser, **"Collections Paris: Fall/Winter 1982,"** in *Interview*, June 1982, pp. 62–63. Printed Matter, Helen Farr Sloan Library, Delaware Art Museum.

Fashion and its purview have given us such art-world-certified practitioners as Irving Penn, Richard Avedon, William Klein, Diane Arbus and Robert Mapplethorpe. But there are others in the industry who have something to show us. I was always delighted with Scott Heiser's semi-abstract runway coverage which appeared in *Interview* during the 1980s. Sometimes details emerged, but the clothes were always alive with motion.[33]

Heiser took runway coverage and made it into an art form, showing a familiar subject in an unfamiliar way.

Traditional fashion runway photographers almost invariably depict the whole figure so as to show the entire ensemble worn by a model. Often they use strobe flash to illuminate details and textures. It is a kind of reportage with the subject on display front and center, rendered crisp and clear, and usually in color, with as much information provided as possible. The sorts of stylistic innovation that can be found in other editorial fashion work do not normally transfer to runway photography, which

Fig. 22. Film still for **The Third Man** (dir. Carol Reed, 1949).

Fig. 23. Film still from **Nosferatu** (dir. F. W. Murnau, 1922).

tends to follow the same visual formulas decade after decade, straight-forwardly capturing the models on the catwalk. Said Heiser, in reference to his deviation from these norms: "If I had to do it straight, the pictures would look just like everyone else's, and that wouldn't do anything for me. I like to concentrate on motion and odd composition, since the girls aren't so interesting after you've seen them 50 times."[34]

Not straight, Heiser's vision is distinctly askew, favoring "odd composition." Walking into a highly conventional scenario such as a runway show, he was able to find a viewpoint that was distinctive, idiosyncratic, emphatically not "everyone else's." He worked around the edges of events, always seeking "another view" of the familiar.

Heiser's uncanny angles and dramatic shadows often recall the German expressionist cinema of Robert Wiene, F. W. Murnau, and others, along with the Anglo-American film noir of the 1940s and 1950s that was influenced by it. In film noir, fragmented figures are seen as partial or total silhouettes shot from oblique vantage points (fig. 22). The visual characteristics of film noir, all present in Heiser's work, include "low-key (high contrast) lighting; non-traditional lighting set-ups; . . . unstable, unbalanced compositions; claustrophobic framing devices; . . . extreme high and low camera angles."[35] Like midcentury fashion photography, film noir had first become a subject of historical reflection and celebration in the 1970s. Indeed, it was between these rediscovered black-and-white worlds—midcentury avant-garde fashion photography on the one hand, and noir cinema on the other—that Heiser found his own world, one of fleeting shadows and stark contrasts, tilted angles and enigmatic backgrounds.

Films such as Carol Reed's *The Third Man* (1949), the defining British noir classic, regularly played at revival houses in New York in the 1970s, as did German expressionist cinema from the 1920s. On July 19, 1976, for example, a double bill of Wiene's *The Cabinet of Doctor Caligari* (1920) and Murnau's *Nosferatu* (1922) ran at the Bleecker Street Cinema (fig. 23). Heiser loved old films and was living at the center of film culture, within minutes of a dozen or more revival and art-film theaters that thrived in the years leading up to the advent of home video. Heiser's close friend Thomas Woodruff recalls him going to the Theater 80 in the East Village to watch the entirety of Leni Riefenstahl's epic four-hour film *Olympia* "several times," an experience that clearly affected his subsequent pictures of public events.[36] Sometimes his images evoke particular films or directors, as when he makes visual reference to *Nosferatu* in an illustration to an *Esquire* story called "A Red-Blooded American Girl," which appeared in May 1981.[37] An unseen figure's shadow reaches out toward an unsuspecting girl (the reaching hand seen in profile was a recurring image in Heiser's work) (fig. 24). More generally Heiser frequently harnessed filmic

devices in his use of spotlighting, views from above or below, the play of form and shadow, close cropping, and so on, all to create a feeling of mystery and tension in his images (plate 16).

Heiser's work, with its black-and-white cinematic quality, was produced exactly contemporaneously with such early postmodernist photography as Cindy Sherman's Untitled Film Still series, following upon the defining 1977 exhibition *Pictures* at Artists Space in New York. As exemplified in the work of Sherman, Jack Goldstein, and many others, frames, film stills, and throwbacks to midcentury cinema were all prominent themes in the art and theory of that time.

If, as Sherman's work reminds us, so-called film stills were in fact not actual frames of the film but rather contrived representations of movie scenes staged for the camera, Heiser's images resemble actual film "stills": low-key frames extracted out of a larger filmic narrative. He wrote, "What happened before or will happen after is literally out of the picture that I take."[38] He avoided the climactic or big, dramatic moment in favor of what he called the "peripheral" moment. Put another way, rather than the "decisive" moment articulated by Cartier-Bresson as an essential balance of forces seized by the photographer,[39] Heiser was interested in those off-kilter or uninvolved moments between actions, what he called "unrelated motion," arguing that "all moments of continuous motion are of equal importance."[40] He said he wanted to notice "every move the performer makes," not just those of obvious interest.[41] In a 1990 photograph made at the Ringling Brothers and Barnum & Bailey Circus, Heiser shows an empty rectangular mat illuminated by a spotlight, while to the side a stagehand holds a safety rope for an aerialist act, looking up at something unseen to us. In the formally taut but empty and uneventful image the rope is precisely echoed by the stripe on the stagehand's pants (plate 38). "I took the picture," he wrote, "because it shows someone on stage not doing anything. . . . The man is not performing. He is just standing."[42] Heiser loved off-moments such as these. Elsewhere he professed a special interest in the motion studies of Eadweard Muybridge, not so much in their entirety but rather taking his isolated frames as freestanding photographs: "Muybridge fascinates me right now. These really static figures, if you took just one of the frames."[43]

As with his point of view, Heiser understood his choice of moments to be in opposition to conventional journalism, which favored the big moment:

> Journalism covers the climaxes of performances . . . I am not a journalist. My most basic intent is to show that the peripheral moments and actions have a life of their own in pictures. This very often renders performers motionless, or suspended in time.

Fig. 24. Scott Heiser, illustration for **"A Red-Blooded American Girl,"** in *Esquire,* May 1981, p. 20. Printed Matter, Helen Farr Sloan Library, Delaware Art Museum.

. . . *An action is fractured into small pieces that are closely exam-ined. The figures then represent a more formal idea of what they may do, rather than exist in a documentation of performance.*[44]

Heiser relished the transitory nature of the fashion show as performance, while seeking to isolate a fixed moment out of the flowing narrative so that it becomes a "formal idea." Able to detach himself from the normal business of photographing the fashion shows as such, he instead found in them an endless font of unexpected imagery. "I have been photo-graphing the collections in Paris for six years," he wrote in the mid-1980s, "and I continue to be fascinated by the diversity of images available for photography."[45]

In 1982, the French film director François Caillat introduced a sequence of Heiser's black-and-white runway images in a special fashion issue of the French photography magazine *Zoom*, where Heiser's work appeared along with articles devoted to Horst, who was no doubt a major inspira-tion to him, Irving Penn, and others renowned in the fashion world. With Heiser, however, Caillat asks, "Is fashion even what we're dealing with here?" He notes that Heiser "makes no illusions about being interested in fashion in the ordinary sense of the word," quoting Heiser: "My photos allude more to the way in which the fashion shows are staged than to the way in which the clothes are displayed. I'm not interested in pro-viding information about fashion . . . I'm not a journalist at all. I try to take photographs that extract the images from their literal context." Caillat observes how Heiser "directs a gaze that is unique from that of fashion industry spectators" by sidestepping the expectation that runway photo-graphs will expose new fashion as it enters the speculative marketplace. Instead, he writes, "Heiser asks himself the reverse question: what will be left once the fashion wanes? Taking a step back from the event, he attempts to bring out more abstract elements." Heiser does so in part by using black and white, "which expunges all superficial characteristics and homogenizes the silhouettes, leaving only their purest traits," and by removing decor and surroundings. Finally, Caillat writes, "the entire economic context is taken out of the photo. The objective of the fash-ion show is forgotten, the spectators absent." Heiser subverts the eco-nomics of the fashion show with his images, which, in the photographer's own words, explore "other, purely visual possibilities."[46]

Also in 1982, Heiser's color runway work was featured in *American Photographer*, which presented him not as a fashion photographer but as a sort of anthropologist, going into the exotic tribal civilization that was early 1980s high fashion, where he "discovered a world of motion and mystery that he has been exploring ever since." *Interview*, that "well-known journal of natural history," was credited with letting Heiser "avoid

the restrictions of fashion reporting, giving him the freedom to dwell on the kinetic beauty of his lost tribes." Heiser's photographs were here again celebrated for their unique point of view and refusal to follow standard procedure: "The pictures that Heiser makes at these shows are like no one else's, partly because he uses available light instead of the usual strobes, but mostly because while his colleagues are straining to show the outfit, he is doing his anthropological best to convey the ethos, in all its weird splendor."[47]

Again Heiser appears detached from the economic goals of the fashion industry. In a later text he commented sarcastically that "In New York, the fashion industry has a lot in common with the rubbish removal industry: business is business," while pointing to the greater cultural importance of fashion in France, where the fashion show becomes an art form in its own right, marked by extravagance, impracticality, and ephemerality: "In Paris, fashion is considered an important cultural manifestation. Certain designers are often criticized for a perceived excess of fantasy at the expense of mass wearability. . . . And the theatrical indulgences so bemoaned by the hard-nosed receive extra lustre from the knowledge that they exist spectacularly and uniquely upon the runway, and then they are done."[48] Heiser focuses not on business but on that "excess of fantasy" and the "theatrical indulgences" that "exist spectacularly and uniquely upon the runaway." As he said around 1985:

> I photograph fashion shows as performances; figures in motion within a specific space. I'm not a journalist, taking pictures to be read for information. I concentrate instead on the pictorial possibilities of the presentations' theatrical content; the efforts of large numbers of people involved in the mounting of a show. In France, the fashion collections are spoken of as a cultural event, as I believe they are. Spectators witness processions of ideas, many of which will never be seen again.[49]

Heiser approaches the fashion shows as a transitory but meaningful art form, not just a display of wares but unique, if fleeting, "processions of ideas."

Ultimately, the runway shows were a subset of the larger concern of Heiser's work as it developed, namely the nature of public events. He said, "My work with fashion shows has led me to other types of performances."[50] Among these were circuses, dog shows, synchronized swimming, boxing, Chinese dance, air shows, and many other kinds of spectacle. Common to all were the actions of performers in front of an audience, which, however, he then abstracted out of their normative context. In 1982, the same year Heiser's fashion work was featured in *Zoom* and *American Photographer,* he published "Circuses," a

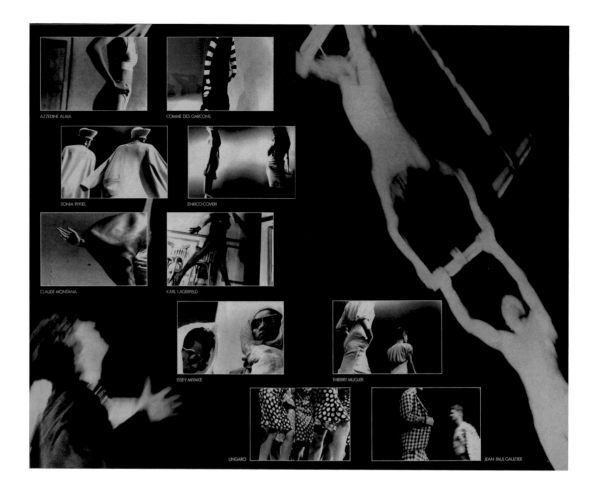

Fig. 25. Scott Heiser, **"Greatest Shows on Earth: The Euro-collections Paris & Milan: Spring '85,"** in *Interview,* May 1985, pp. 90–91. Printed Matter, Helen Farr Sloan Library, Delaware Art Museum.

wordless photo essay on the European circus, in the London magazine *Creative Camera.*[51]

The photographic sequence or photo-essay was an inherently magazine-based approach, but it also had fine-art-photography associations ranging from Minor White to Ralph Gibson. Heiser no doubt knew of Gibson's wordless sequences in his trilogy of books from the early 1970s: *The Somnabulist* (1970), *Deja-Vu* (1972), and *Days at Sea* (1974)—the last from the same year that Gibson and Heiser were both featured with portfolios in *35mm Photography* magazine's "Gallery 35."[52] Gibson used a 35mm camera to produce visually elegant, psychologically uncanny images marked by high contrast and at times claustrophobic spaces.

For his part, Heiser credited his discovery of the photo-essay to a professional assignment he had done, specifically a fashion slide show he produced for *Harper's Bazaar:* "It was then that I discovered the possibilities of doing photo essays, even with as commercial a subject as fashion shows."[53] A commercial (i.e., predictable) subject could nonetheless be an occasion to begin to explore a personal point of view.

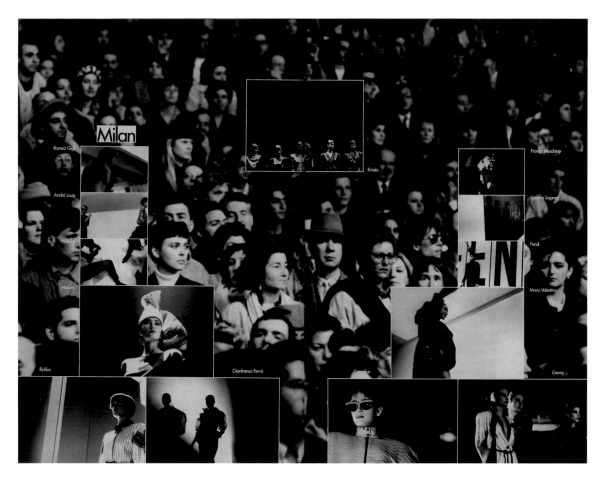

Fig. 26. Scott Heiser, **"Standing Room Only: Fashion: Euro-collections Fall '86,"** in *Interview*, August 1986, pp. 110–11. Printed Matter, Helen Farr Sloan Library, Delaware Art Museum.

In the mid-1980s, *Interview* ran a succession of layouts using Heiser's public-event photographs as backdrops for his runway features. Each had a theme, at once witty and apropos. The spreads played up the relation between the runway shots and the background images, taken from various realms of public display. These included bodybuilders ("Strength of the New York Collections," Fall/Winter 1984); the zoo ("Wild Life: The Eurocollections Fall/Winter '85," with images of animals taken at the Parc zoologique in Paris); the circus ("Greatest Shows on Earth: The Euro-collections Paris & Milan: Spring '85," featuring the European circus) (fig. 25); and even the art museum ("Profiles in Fashion: The Eurocollec-tions Spring/Summer '86" showing works photographed in the Picasso Museum). For the story called "Standing Room Only: Fashion: Eurocol-lections Fall '86," images of an audience from a different event served as a backdrop to the photographs of catwalk "performers"[54] (fig. 26). Overall these spreads suggest the many possible metaphorical affinities between fashion shows and circuses, zoos, sporting events, and the like, hinting at a larger context for Heiser's fashion shots, one of ironic critique.

Heiser ("taking a step back from the event") asks us to consider, too, how photography is part of the spectacle itself: the fashion paparazzi at the runway shows, the tourist with a camera at the circus, are, in a sense, part of the event. Without them the spectacle would not be complete: it is, in a very real sense, for them. As a photographer, however, he tries to take a different, uninvolved posture toward the event, a "gaze that is unique," another view. Kim Hastreiter, the influential editor of the alternative fashion magazine *Paper*, where Heiser contributed starting in 1986, wrote that "Scott's vision was that of a person far removed from the reality of a situation that was at the same time endearing to him."[55] As Heiser himself wrote, "My photos are intentionally remote."[56]

In 1987, Richard Martin featured numerous examples of Heiser's work in his popular exhibition and publication for New York's Fashion Institute of Technology, *Fashion and Surrealism*, including Heiser's picture of Thierry Mugler's "bird dresses and bird cage" on the catalogue's title page (plate 13).[57] The way they are labeled, however, Heiser's photographs seem to function for Martin principally as literal documents of the surrealistic fashion design of the 1980s, rather than as examples of a surrealistic approach to fashion photography (Heiser as photographer is given secondary credit to the designer; in other examples involving the photographers Man Ray or Horst, the order is reversed). For Heiser, however, such a distinction—between the act of photographing existing or found realities and the use of photography as a vehicle for sheer fantasy—would not hold. His oneiric images were for him the opposite of journalism in the sense of literal reportage, even as he found his incongruities, disjunctions, duplications, reflections, and an overall "excess of fantasy" not in the studio or the darkroom but in the world itself. Heiser's 1989 exhibition at the Paula Allen Gallery in New York was covered in the *New York Native* as part of a three-show review, "A New Surrealism." In it Heiser explained the relation between the deliberate artifice of a surrealistic fashion photographer like Beaton, who spun visual fantasies in the studio or on the set, and the type of strangeness that he himself was able to distill from an otherwise "journalistic" situation.

> I started out doing portraits, being inspired by Cecil Beaton, all that artificiality. Then, years ago, I started doing fashion shows for *Interview* where I made photos out of the stuff [of the performance], not the clothes. Then I branched out and did circuses. From there, I went everywhere, wherever there's something interesting. I scan the papers every week, looking for things. In a sense, it is connected to my beginnings with artificial set-ups.

Instead of creating the artifice for the camera, Heiser now witnessed it, looking from his own unique vantage point. "Like they say," Heiser added, "real life does get more weird than you can dream up."[58]

Caillat had recognized this dialectic of found subject and personal vision as being at the core of Heiser's work: "The fundamental quality of his images likely rests in their original circumstances, which he wishes to preserve: Heiser is simultaneously intent and detached, confronting a subject in order to better transform it."[59] The paradox, then, is that Heiser is both direct and indirect. He works out in the world, like a journalist, but makes images that are far from being literal reports.

In a series of draft letters starting in 1988, Heiser developed a proposal for a studio photography course that would, as he explained it, "personalize the photographing of public events. Students would be asked to balance personal and found aesthetics when working . . . [and] would be encouraged to make creative choices free of any literal considerations. The course would include discussions about ways of seeing events and performances as raw material for picture making." After a discussion of "the nature of making personal photographs in an environment that tends to be thought of strictly as journalistic territory," students would be asked "to approach events with a deliberate disregard for literal meanings and conventional concerns."[60]

Here again, the disparaged term "journalism" refers to "literal meanings" and "conventional concerns." While Heiser did work for mainstream magazines, taking assignments to pay the bills, he fittingly always found his real home, as a photographer, in the downtown, alternative press, first at *Interview* and then, after Warhol's death, at *Paper,* which its editor Kim Hastreiter once referred to as the "anti-*Vogue.*"[61]

Heiser's monthly byline feature for *Paper* consisted of a single photograph, made at a public event or, increasingly, on the street (in the subway, etc.) with a caption written by him. The feature had several related titles over the years. First called "Room for a View," it subsequently became "Room for Another View," then simply "Another View," and after that, "Another Clue." Like *Interview,* albeit in a more restrained visual format than the spread upon spread devoted to the runway shows, *Paper* offered Heiser, in its pages, room for a view of his own.

His monthly contribution to *Paper* would have obviously compared, in the world of the downtown press of the 1980s, to the highly visible weekly feature that had run in the *Village Voice* since 1982, Sylvia Plachy's quirky "Unguided Tour." Each week Plachy published a single, uncaptioned, full-frame photograph with surreal or witty overtones. Like Plachy evincing a (sometimes dark) sense of humor, Heiser presented images that were self-contained, out of normal context, and ultimately "non-journalistic,"

in the sense that they did not sustain or support a newsworthy "story" but rather spoke first and foremost as pictures, made from an independent if not idiosyncratic viewpoint and depicting the margins of daily life. "I want my pictures to suggest a strong preference for the overlooked," wrote Heiser, "as well as the unknowable."[62]

Ultimately, both *Interview* and *Paper* allowed Heiser to do what he wanted, which was to "make photos as photos." In a two-decade career, he never lost his initial enthusiasm for photography as a unique, and uniquely individual, mode of inquiry, grounded in the development of what he called "a strong personal viewpoint."[63] He made the medium his own.

> [It] is my point of view that informs my whole way of working. I do not set out to reinvent photography, but I am aware that photography requires decisions be made at several stages in its progress. For me to work as I do, I must frequently refer back to the original impulses that made me want to be a photographer in the [first] place. These impulses were, in fact, first developed and encouraged when I was in school, and have continued to exert [an] influence on my work.[64]

Heiser's approach never stopped reflecting the influence of Callahan and the photography program at RISD. An earlier student of Callahan's, Ray K. Metzker, explained the impact of the teacher on his students, recounting the passion and conviction with which Callahan would insist, "If you want to make pictures, you got to love making pictures."[65] When Heiser started working for Turbeville in the early 1970s, he excitedly described his time in Providence (which she called a "breeding ground" for artistic photography) to her. "He talked a lot about how it was possible to do very experimental work up there," she remembers, "and how it influenced his way of seeing and working."[66] Believing that, ideally, a photographer's "way of seeing can and should run parallel to the concerns of a work situation,"[67] Heiser continued to experiment and explore possibilities in his work for *Interview,* and then at *Paper* and elsewhere.

Hastreiter paid Heiser tribute in the pages of *Paper* following his premature death in the fall of 1993. "Scott," she said, "saw the world around him through eyes of contrast." Indeed, Heiser saw contrast not only in terms of light and dark but in terms of presence and absence, motion and stasis, reality and fantasy, self and other (plate 11). His photographs could be laden with irony or evince a dark view of the world, but they also found formal beauty and enduring mystery in everything from fashion shows to athletic events, from dog shows to subway platforms, all viewed with what Hastreiter described as a detached yet affectionate eye. "But most of all," she concluded, "Scott was in love with what he did. He lived for taking pictures."[68]

Notes

1. "Collections Paris: Spring/Summer 1982, Photographed by Scott Heiser," *Interview* 11, no. 12 (December 1981): 98–101.

2. Scott Heiser, untitled statement, c. 1985, draft letter to Hisami [Kuroiwa], Scott Heiser Papers, box 2, Delaware Art Museum.

3. Jacob Deschin, "Callahan Teaching Method," *New York Times*, January 12, 1969, D33.

4. Trucia Cushner, "Taxi!" *Interview*, no. 26 (October 1972): 38.

5. Charles Hagen, "'Faces Photographed: Contemporary Camera Images,' Grey Art Gallery," (Review), *Artforum* 21, no. 6 (February 1983): 78.

6. *Faces Photographed: Contemporary Camera Images* (New York: Grey Art Gallery and Study Center, New York University, 1982).

7. Scott Heiser, untitled statement, c. 1984, Heiser Papers, box 2.

8. Randy Kennedy, "Scott Heiser, Leader and Innovator, 44, in Fashion Pictures," *New York Times*, October 23, 1993, 10.

9. Scott Heiser letter to Delaware Art Museum, September 14, 1993, Heiser Papers, box 1.

10. Scott Heiser résumé, c. 1976, Heiser Papers, box 1; "Fashion: Paris Ready-to-Wear Preview: The New Femininity," *Vogue* 165, no. 1 (January 1975): 94–99.

11. Gene Thornton, "Fashion Photography: An Art of Democracy," *Fashion Photography: Six Decades* (Hempstead, NY: Emily Lowe Gallery, Hofstra University, 1975), n.p.

12. Dorothy Seiberling, "Modes and Masters of Fashion Photography," *New York*, October 27, 1975, 42.

13. Owen Edwards, "Fashion Photography Is Good to Look At, but Not Always Good," *Village Voice*, January 12, 1976, 38.

14. Heiser résumé, c. 1976.

15. Douglas Davis, "Focusing on Fashion," *Newsweek*, November 10, 1975, 113–14.

16. Hilton Kramer, "The Dubious Art of Fashion Photography," *New York Times*, December 28, 1975, D 28.

17. Cecil Beaton and Gail Buckland, *The Magic Image: The Genius of Photography from 1839 to the Present Day* (Boston: Little Brown and Company, 1975), 275.

18. Robert Brandau, ed., *De Meyer* (New York: Knopf, 1976).

19. Richard Avedon, *Avedon: Photographs, 1947–1977* (New York: Farrar, Straus, and Giroux, 1978); *Spontaneity and Style: Munkácsi: A Retrospective*, exh. cat. (New York: International Center of Photography, 1978).

20. Nancy White and John Esten, *Style in Motion: Munkácsi Photographs, '20s, '30s, '40s* (New York: Clarkson N. Potter, 1979).

21. Irving Penn, *Inventive Paris Clothes, 1909–1939: A Photographic Essay by Irving Penn* (New York: Viking, 1977).

22. Nancy Hall-Duncan, *The History of Fashion Photography* (Rochester: International Museum of Photography; New York: Alpine, 1979); Polly Devlin, *Vogue Book of Fashion Photography, 1919–1979* (New York: Simon and Schuster, 1979).

23. Scott Heiser, "Runway: New York," *Interview* 8, no. 12 (December 1978): 73–78.

24. Scott Heiser and Daniela Morera, "The Collections: Paris and Milan," *Interview* 9, no. 5 (May 1979): 64–72.

25. Heiser, untitled statement, c. 1984.

26. "Flash! The Lost Tribe of Seventh Avenue," *American Photographer* 8, no. 5 (May 1982): 89.

27. *Fashion*, "Models and Photographers" (Warhol TV), Take 10 Manhattan Cable TV, 1979. Collection of the Paley Center for Media, New York, NY.

28. Marc Balet, interview with the author, April 5, 2013.

29. *Alexey Brodovitch and His Influence*, exh. cat. (Philadelphia: Philadelphia College of Art, 1972), 19.

30. "Brodovitch on Photography" (orig. 1961), in *Alexey Brodovitch*, exh. cat. (Paris: Grand Palais; Ministère de la Culture, 1982), 124.

31. *Fashion*, "Models and Photographers."

32. Balet, interview with the author.

33. Glenn O'Brien, "Re-Make/Re-Model: Jessica Craig-Martin," *Frieze*, no. 60 (June-August 2001), http://www.frieze.com/issue/article/re_make_re_model/.

34. "Flash! The Lost Tribe," 89.

35. Nancy J. Steffen, "*The Dark Side of the Screen: Film Noir* by Foster Hirsch" (book review), *Journal of the University Film and Video Association* 34, no. 3 (Summer 1982): 59.

36. Thomas Woodruff, comments to the author in an e-mail, April 27, 2013.

37. Bob Greene, "A Red-Blooded American Girl," *Esquire*, May 1981, 20.

38. Scott Heiser, untitled statement, c. 1985.

39. See Henri Cartier-Bresson, "The Decisive Moment, 1952 (an excerpt)" in Vicki Goldberg, ed., *Photography in Print: Writings from 1816 to the Present* (Albuquerque: University of New Mexico, 1981), 384–86.

40. Heiser, untitled statement, c. 1985.

41. Scott Heiser, untitled statement, c. 1991, Heiser Papers, box 2.

42. "Scott Heiser," *Night*, no. 20 (1991): n.p.

43. David Hirsh, "A New Surrealism," *New York Native*, no. 310 (March 27, 1989): 21.

44. Heiser, untitled statement, c. 1985.

45. Ibid.

46. François Caillat, "Scott Heiser," *Zoom* 92 (1982): 90. Translated by Maeve Coudrelle.

47. "Flash! The Lost Tribe," 89.

48. Scott Heiser, untitled caption draft, Heiser Papers, box 2.

49. Heiser, untitled statement, c. 1985.

50. Heiser, untitled statement, c. 1984.

51. Scott Heiser, "Circuses," *Creative Camera*, no. 216 (December 1982): 770–75.

52. "Gallery 35: Scott Heiser," *35mm Photography* (Spring 1974): 76–79.

53. Heiser, untitled statement, c. 1984.

54. Scott Heiser, "Strength of the New York Collections," *Interview* 14, no. 9 (September 1984): 153–58; "Greatest Shows on Earth: The Eurocollections Paris & Milan: Spring '85," *Interview* 15, no. 5 (May 1985): 89–93; "Wild Life: The Eurocollections Fall/Winter '85," *Interview* 15, no. 8 (August 1985): 89–94; "Profiles in Fashion: The Eurocollections Spring/Summer '86," *Interview* 16, no. 2 (February 1986):104–8; "Standing Room Only: Fashion: Eurocollections Fall '86," *Interview* 16, no. 8 (August 1986): 109–12.

55. Kim Hastreiter, "In Memoriam Scott Heiser, 1949–1993," *Paper*, December 1993, 20.

56. Scott Heiser, untitled statement, c. Feb. 1992, Heiser Papers, box 2.

57. Richard Martin, *Fashion and Surrealism* (New York: Rizzoli; Fashion Institute of Technology, 1987).

58. Hirsh, "A New Surrealism," 21.

59. Caillat, "Scott Heiser," 90.

60. Scott Heiser, course proposal c. 1989, Heiser Papers, box 1.

61. Max Padilla, "Q & A with 'Geoffrey Beene' Author Kim Hastreiter," *Los Angeles Times*, November 16, 2008, http://www.latimes.com/features/la-ig-beene16-2008nov16,0,6271753.story.

62. Heiser, untitled statement, c. Feb. 1992.

63. Scott Heiser, draft letter to Alice Beck-Odette, c. 1989, Heiser Papers, box 1.

64. Heiser, course proposal, c. 1989.

65. "Callahan as Teacher: His Legacy Viewed by His Students," *The Archive* (Tucson: Center for Creative Photography, University of Arizona), no. 35 (October 2007): 55.

66. Deborah Turbeville, interview with Heather Campbell Coyle, May 23, 2012.

67. Heiser, draft letter to Alice Beck-Odette.

68. Hastreiter, "In Memoriam," 20.

FASHION

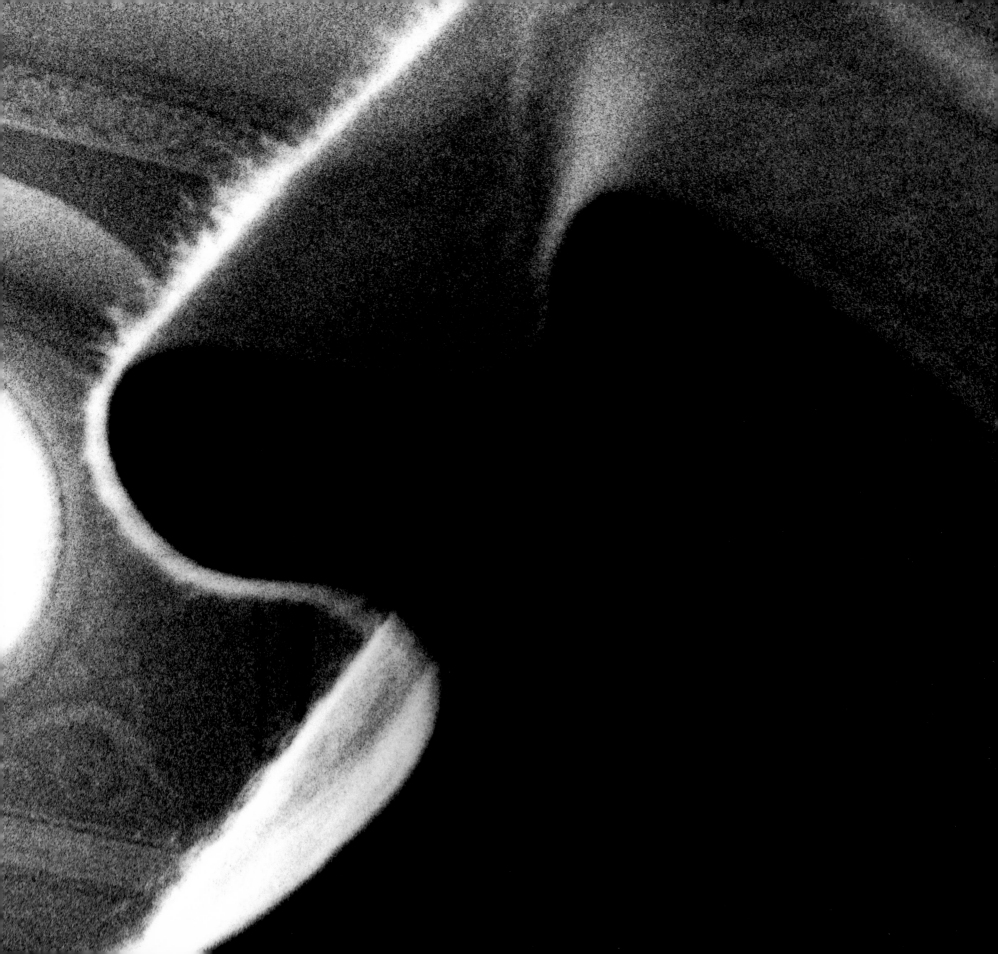

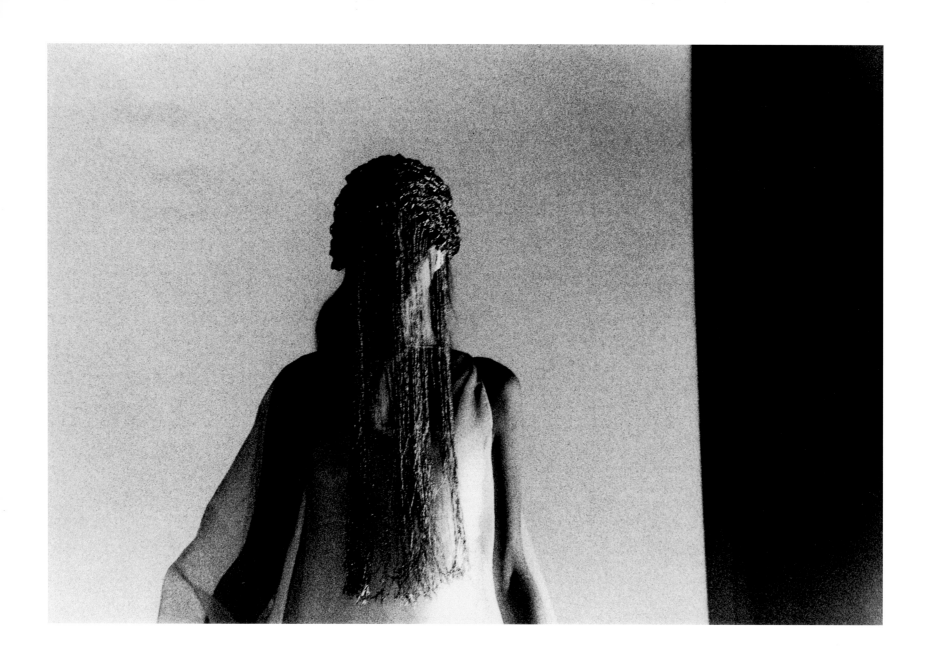

Plate 1 Scott Heiser, **Mary McFadden, New York,** 1978

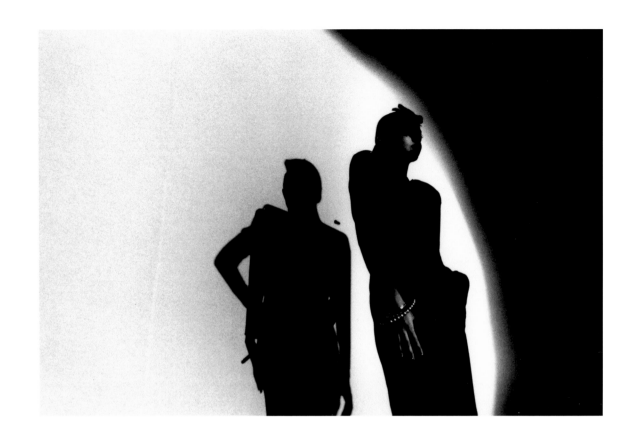

Plate 2 Scott Heiser, **Jean Claude de Luca, Paris,** 1979

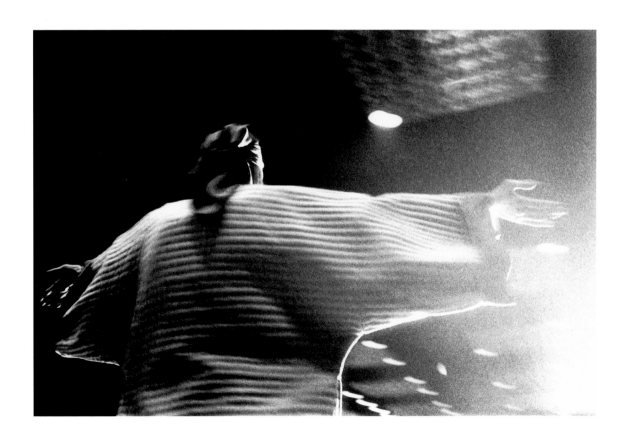

Plate 3 Scott Heiser, **Michael Vollbracht, New York,** 1980

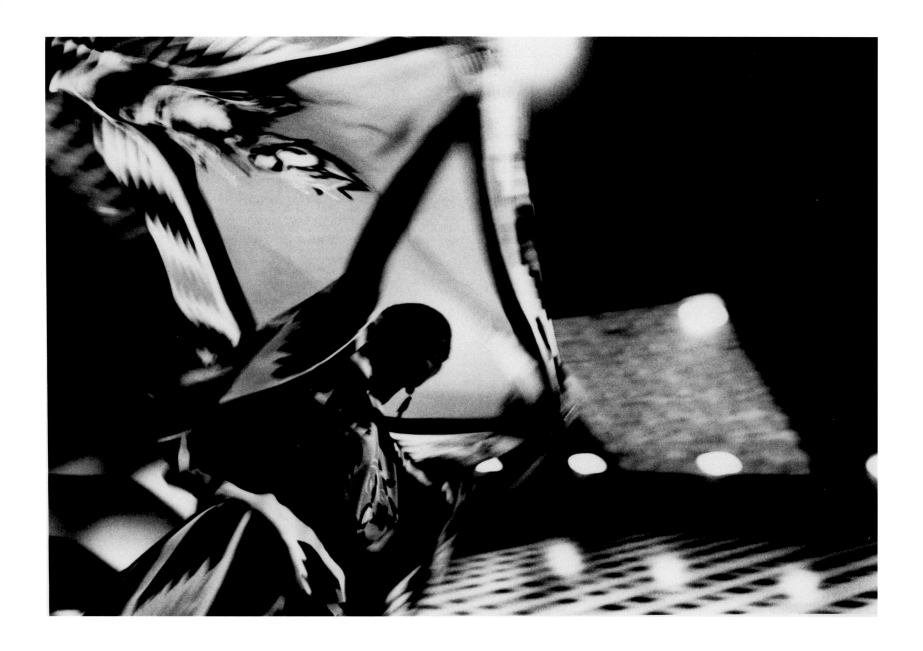

Plate 4 Scott Heiser, **Michael Vollbracht, New York,** 1980

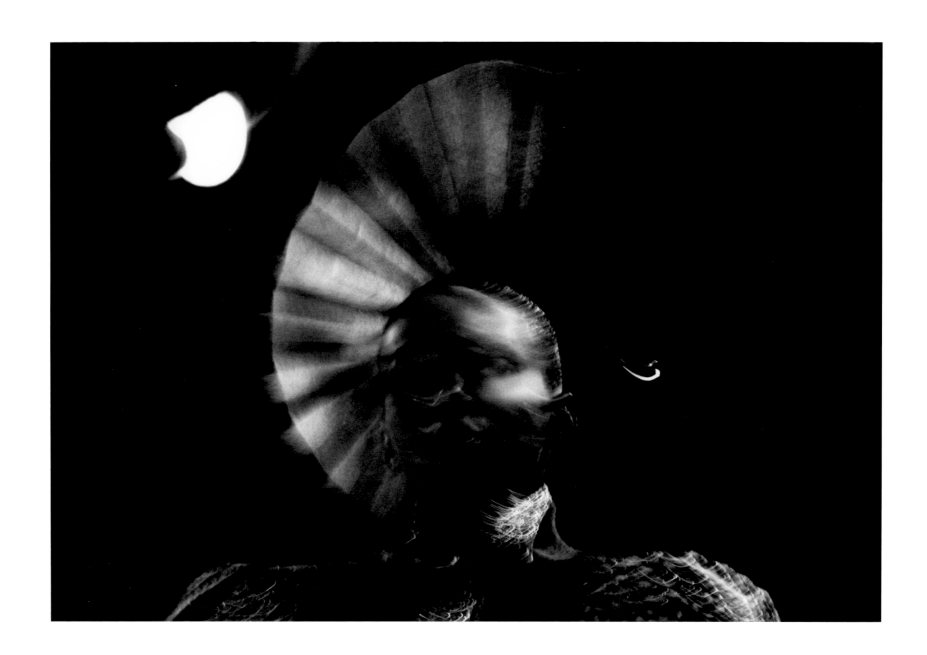

Plate 5 Scott Heiser, **Kansai Yamamoto, New York,** 1980

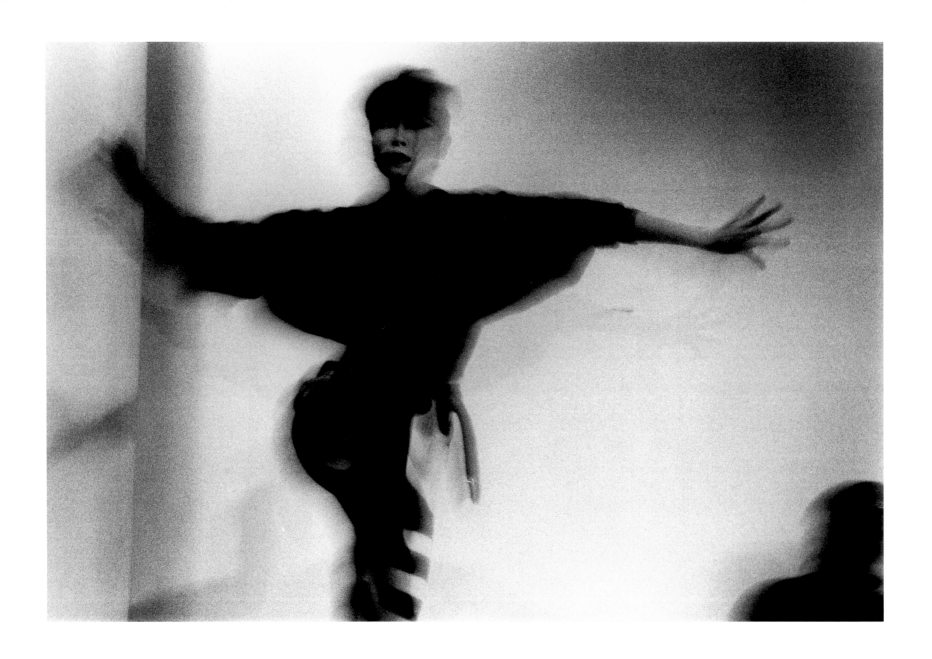

Plate 6 Scott Heiser, **Kansai Yamamoto, New York,** 1980

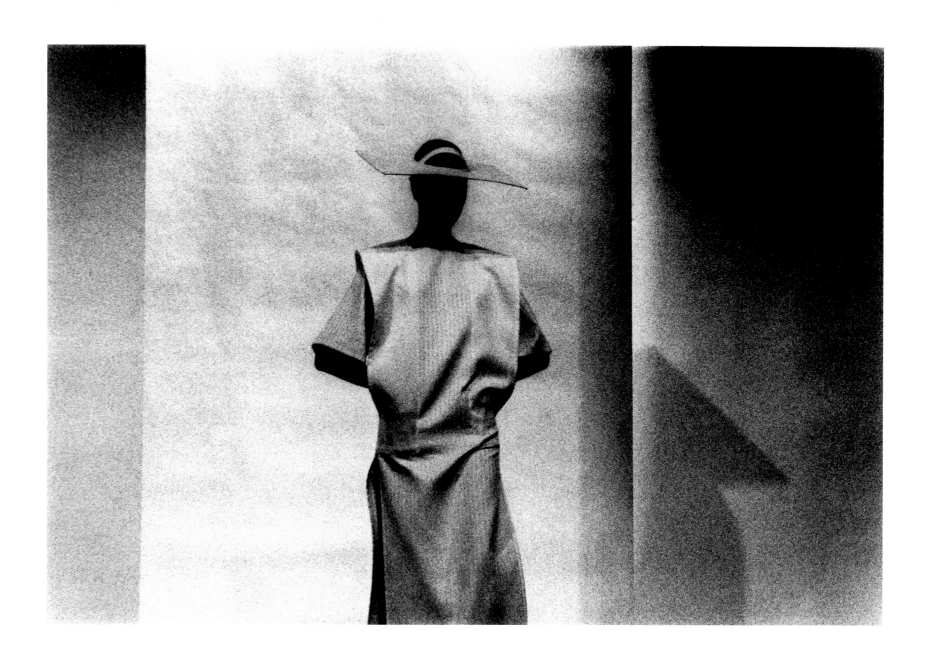

Plate 7 Scott Heiser, **Shamask, New York,** 1980

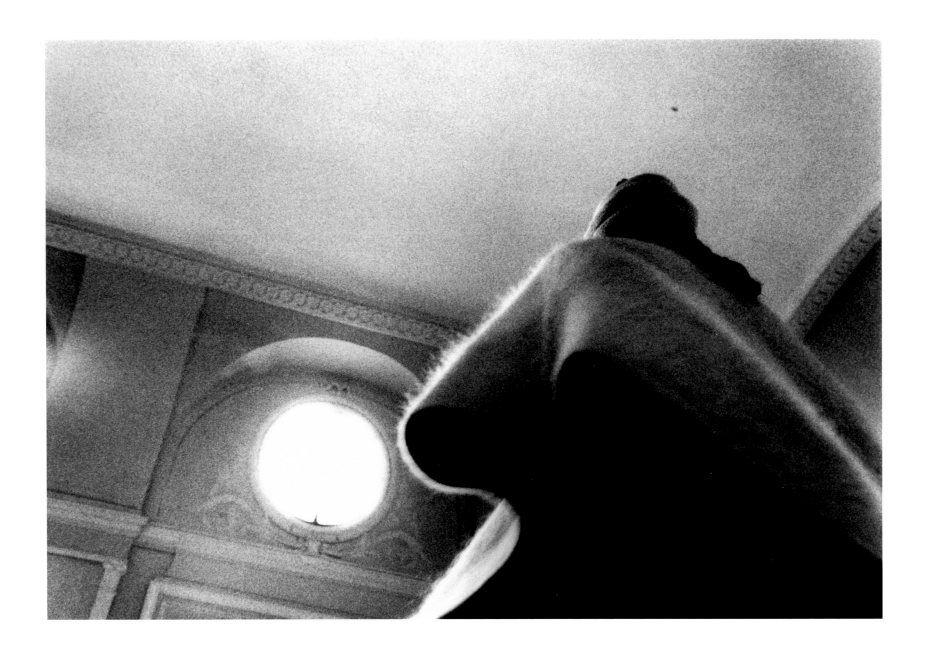

Plate 8 Scott Heiser, **Madame Grès, Paris,** 1980

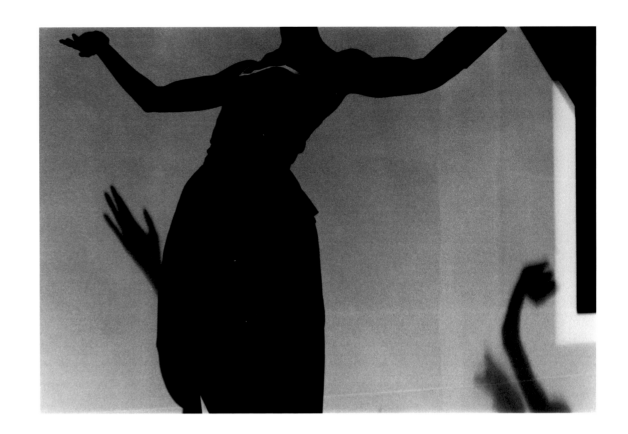

Plate 9 Scott Heiser, **Basile, Milan,** 1981

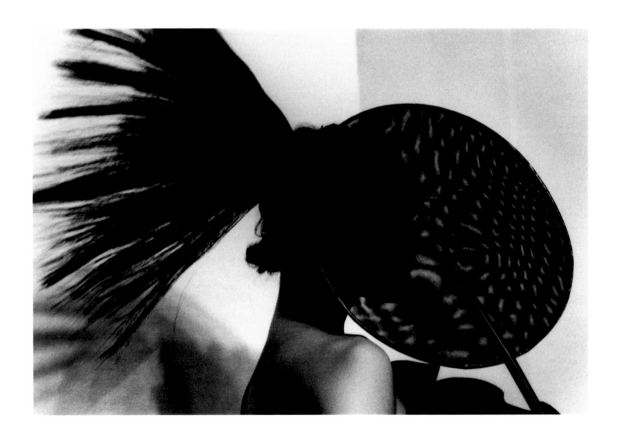

Plate 10 Scott Heiser, **Issey Miyake, Paris,** 1981

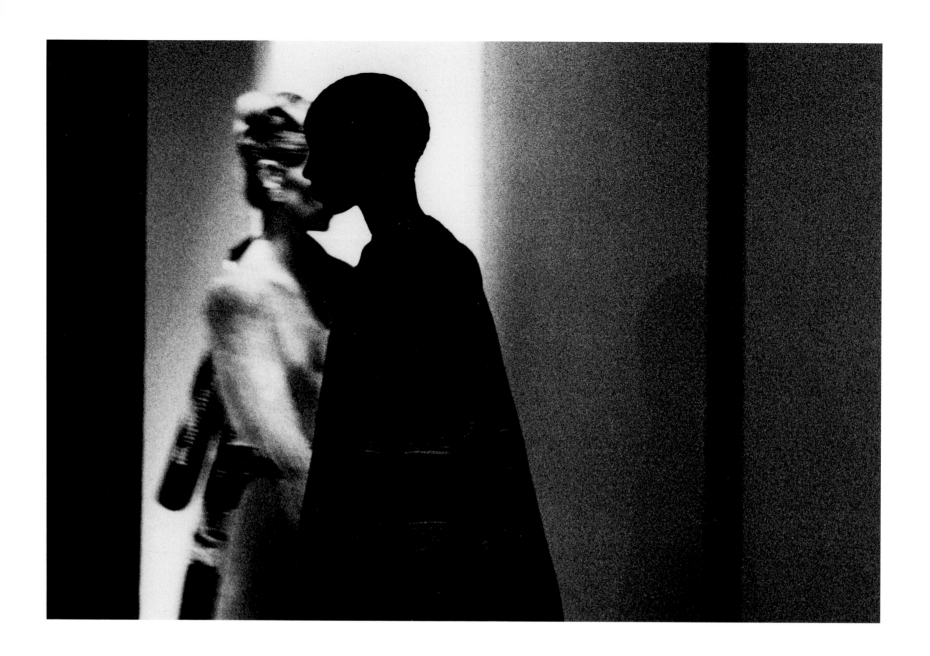

Plate 11 Scott Heiser, **Mary McFadden, New York,** 1981

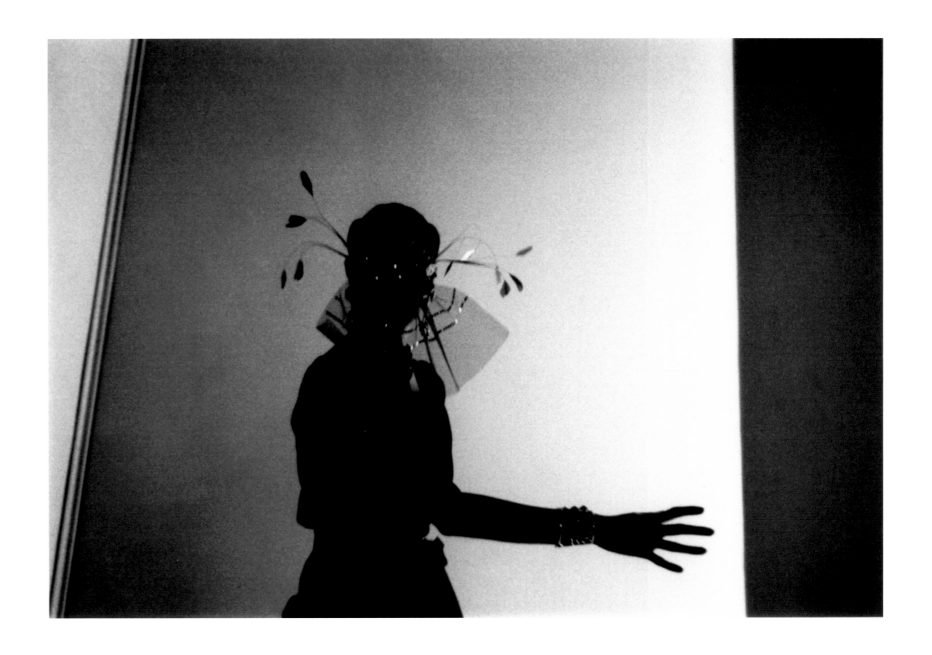

Plate 12 Scott Heiser, **Yves Saint Laurent, Paris,** 1982

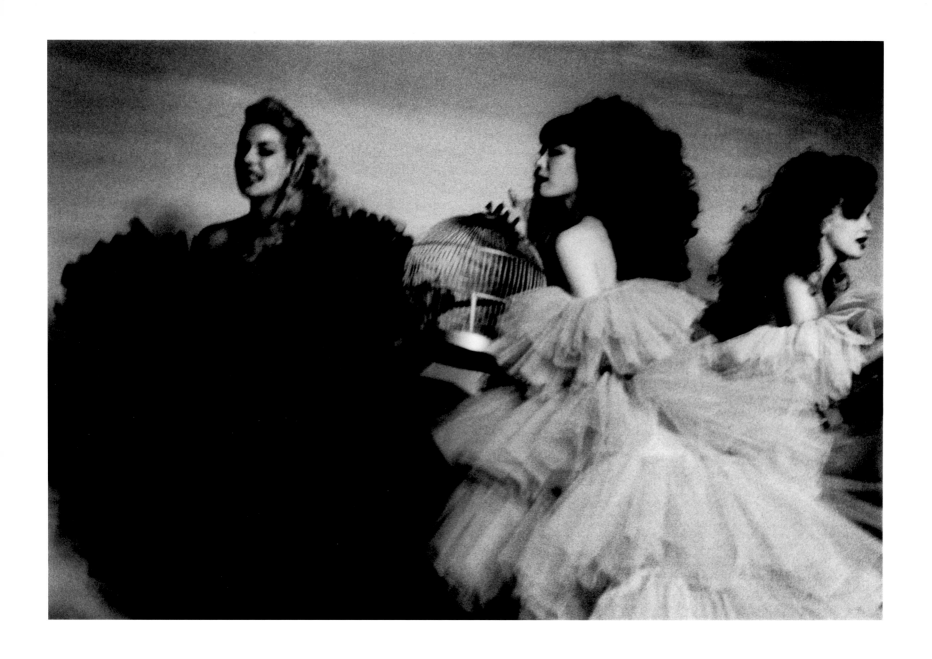

Plate 13 Scott Heiser, **Thierry Mugler, Paris,** 1982

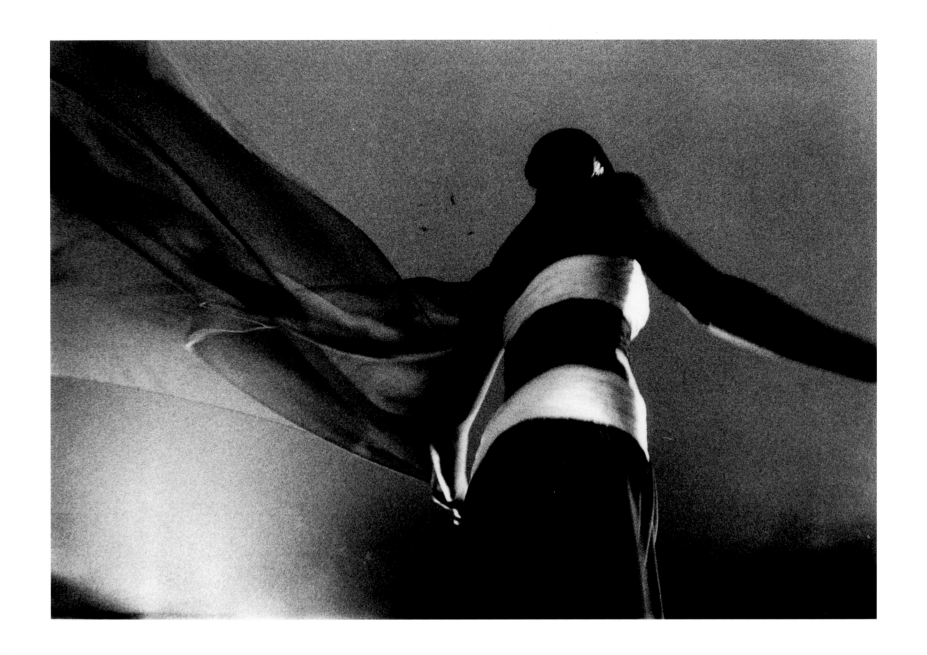

Plate 14 Scott Heiser, **Givenchy, Paris,** 1983

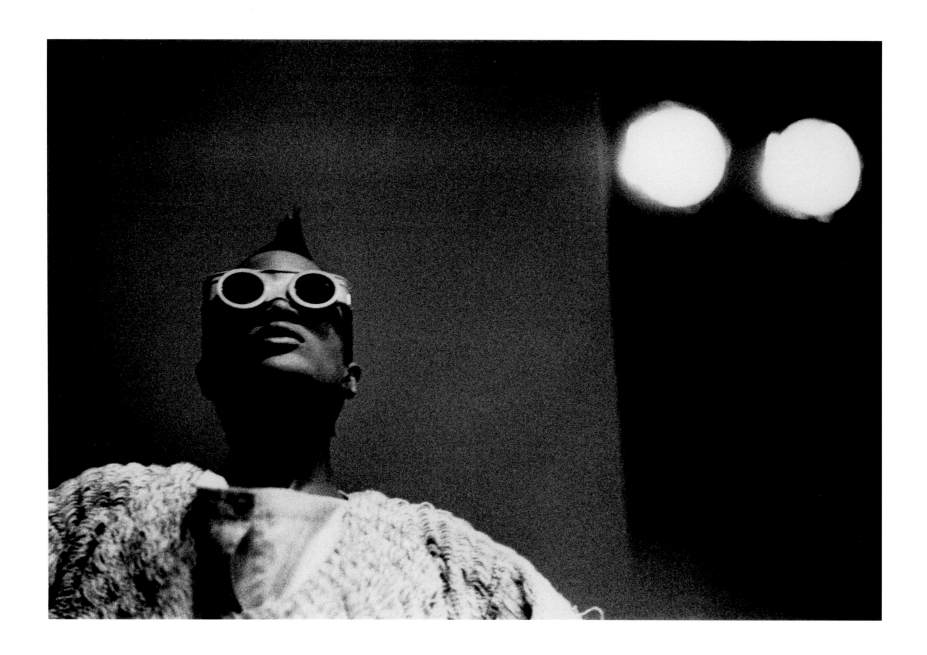

Plate 15 Scott Heiser, **Issey Miyake, Paris,** 1983

Plate 16 Scott Heiser, **Luciano Soprani, Milan,** 1984

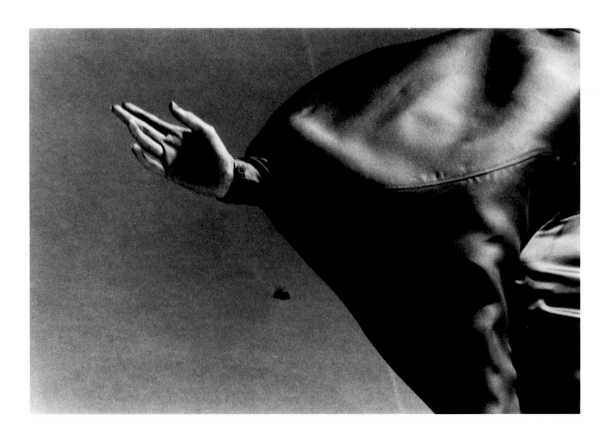

Plate 17 Scott Heiser, **Claude Montana, Paris,** 1984

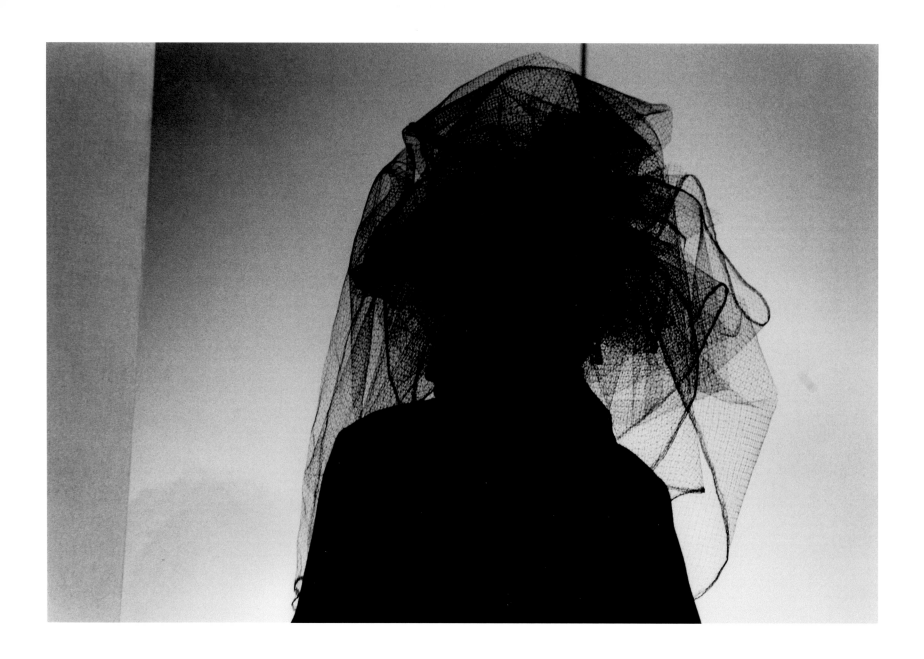

Plate 18 Scott Heiser, **Matsuda, New York,** 1984

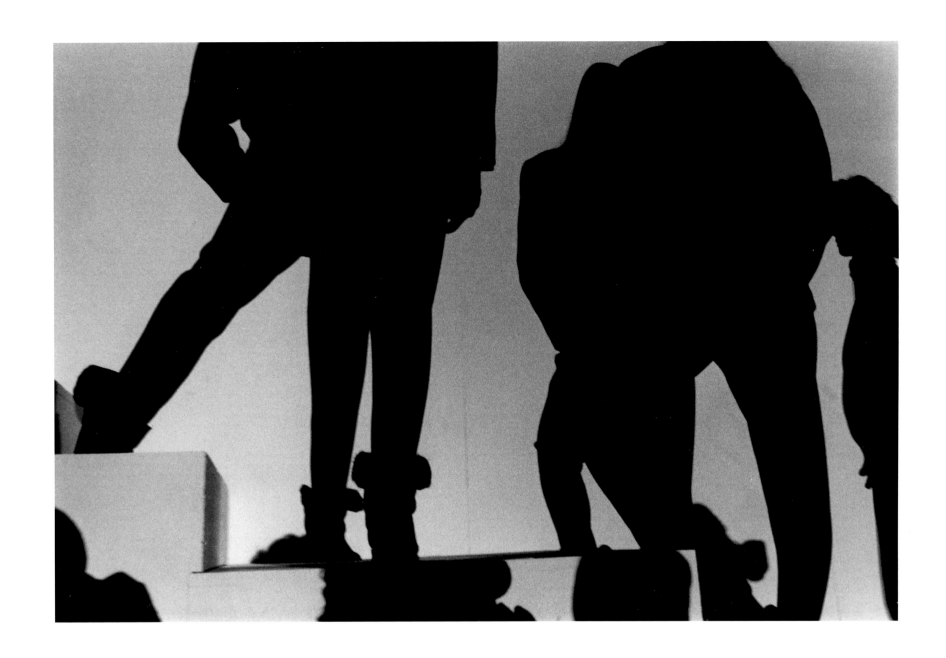

Plate 19 Scott Heiser, **Byblos, Milan,** 1985

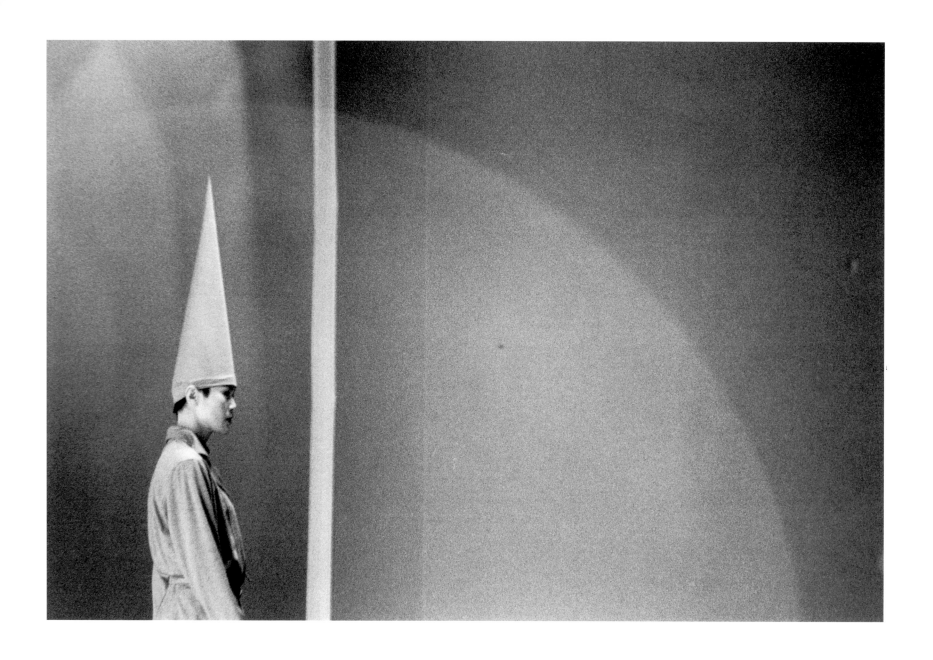

Plate 20 Scott Heiser, **Kenzo, Paris,** 1985

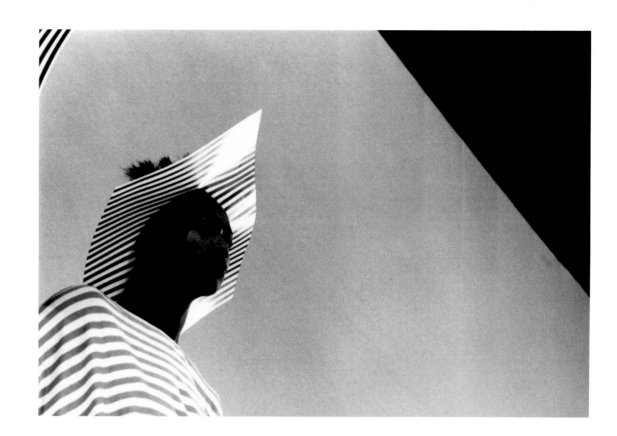

Plate 21 Scott Heiser, **Issey Miyake, Paris,** 1985

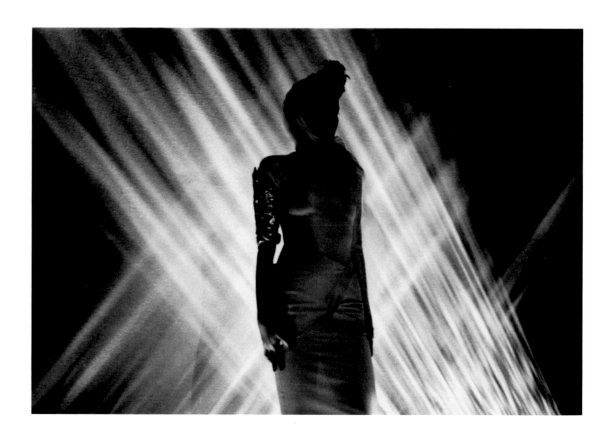

Plate 22 Scott Heiser, **Claude Montana, Paris,** 1985

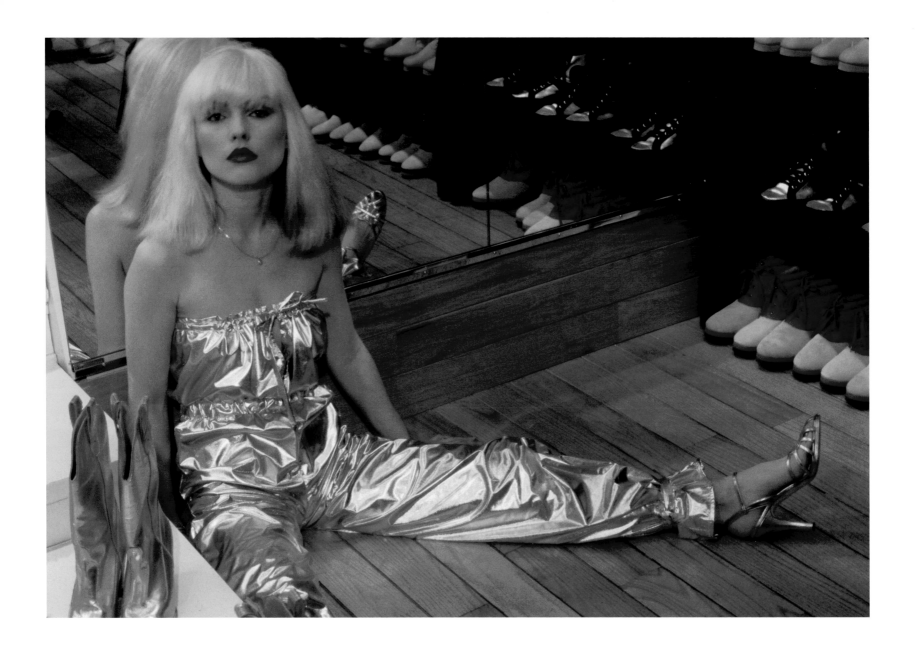

Plate 23 Scott Heiser, **Deborah Harry at Fiorucci, New York,** 1977

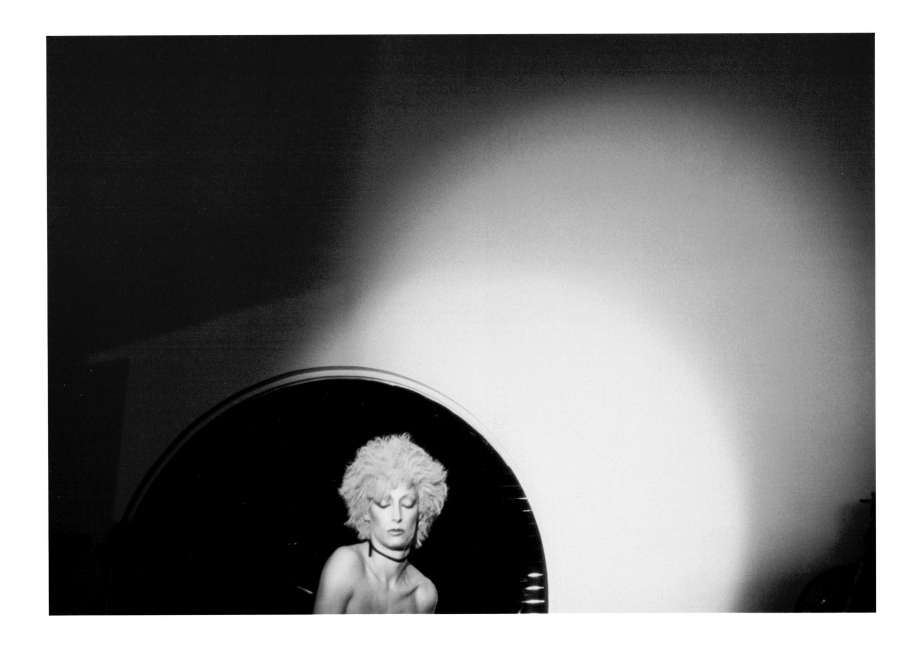

Plate 24 Scott Heiser, **Betsey Johnson,** not dated

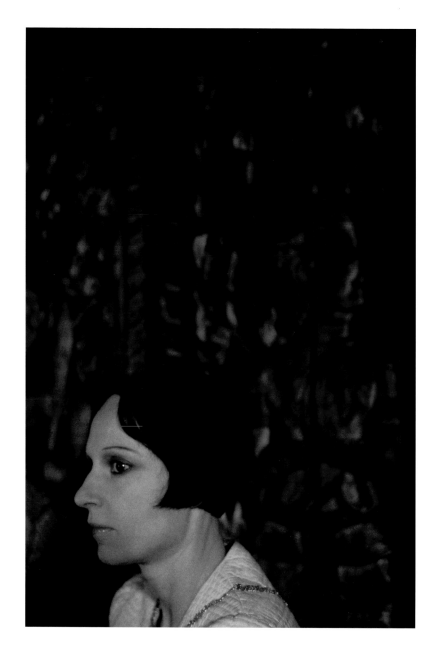

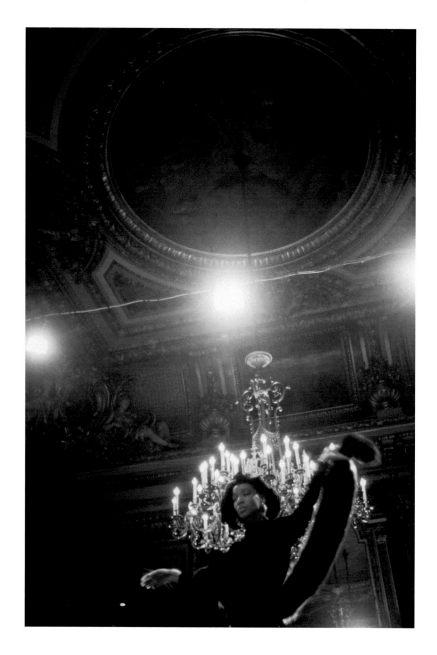

Plate 25 Scott Heiser, **Mary McFadden,** 1981

Plate 26 Scott Heiser, **Yves Saint Laurent,** not dated

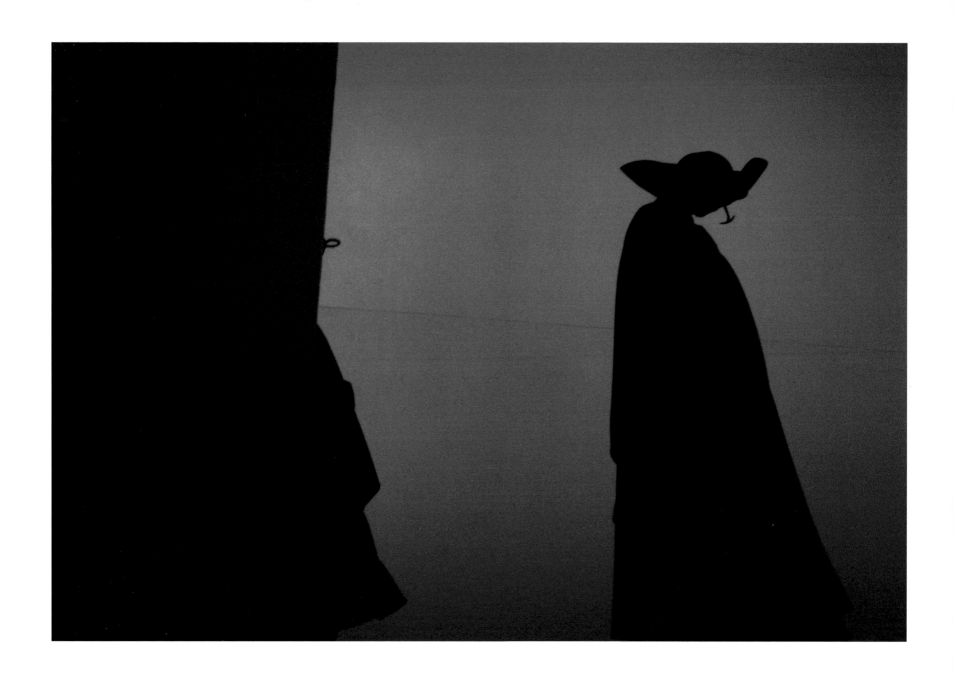

Plate 27 Scott Heiser, **Pauline Trigère,** not dated

An Appreciation

HILTON ALS

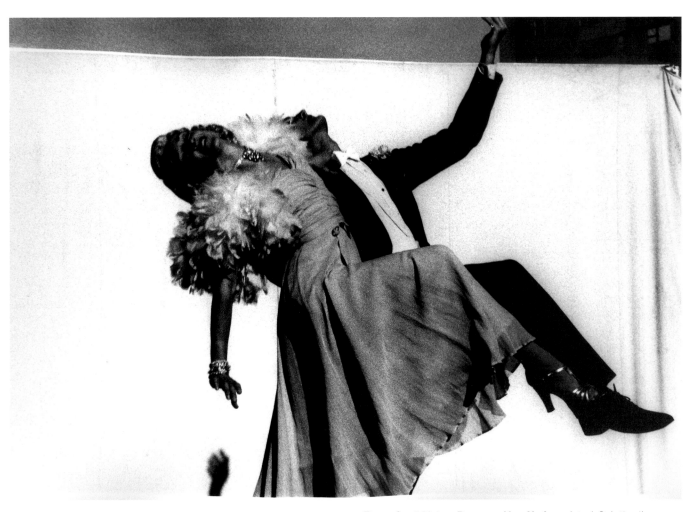

Fig. 27. Scott Heiser, **Dancers, New York,** undated. Gelatin silver print, 8 x 12 inches. Estate of the Artist.

I first met Scott Heiser through the photographer Darryl Turner. This was in 1990, or 1991, or maybe a little before then; I can't quite remember what year it was, exactly. I was the picture editor at the *Village Voice*, I remember that much, but maybe I don't want to remember what year it was, actually, because that would mean remembering, looking things up, and remembering can sometimes lead to a certain sadness about all the people I never get to see anymore, and what makes it worse is that for the most part the people who are no longer here, the people I don't see anymore, are the people I want to see above all others, Scott included.

In any case Darryl was keen for me to meet Scott because Darryl and his ever-present, empathetic eye had, by then, picked up on the kind of photographs I loved, which is to say he quickly figured out I was particularly intrigued by photographs that were about photographs, which is to say I was captivated by images that spoke beyond the periphery of the frame and echoed in my mind as images I could relate to emotionally and so on while they addressed the general issue—the conundrum—of

photography, its evanescence and intractability. Scott's pictures were all about edges—the model leaving the frame, trailed by a bit of chiffon or silk; the acrobat's hand or foot waving or winking at the audience—and it was in the details he captured along the edges that told us more about an event, a person, an atmosphere, than flat-out documentary photography did or could, because the purely journalistic eye is, for me at least, just that—flat, literal, less the record of a mind than a plain old record, nothing extra. Most of Scott's pictures are in black and white, just "like" documentary photographs; he was Walker Evans's and Robert Frank's sensitive, queer little brother, maybe, upsetting their "truth," with his real-life fabrications in pictures that are specific in the way a poem has to be specific while retaining its own silences and mysteries—that which cannot be explained.

How can you explain a talent like Scott's, or his heart? I think Darryl might have shown me Scott's work from when Darryl was the art director for the *East Village Eye* and he used Scott's pictures. I didn't know either of them then, or maybe I saw the paper on my own and I took note of Scott's work then, I don't remember. But of course I had seen Scott's fashion pictures in *Details* and *Interview*; I never forget a photographer I like, and I loved Scott's pictures from the first. There was so much air in them, and the blacks were so solid, but everything had the feeling of rain running down a windowpane: you couldn't catch his pictures; they were melancholy, like the rain. Anyway, I might have called Scott at Darryl's suggestion, because I asked him to come in with his book, and what I recall from that meeting was how shy he was and how much he wanted to like me; I think he saw all magazines and newspapers as a kind of place of hope—a new place or world that would include the world of his pictures.

One picture of Scott's I loved in particular appeared not in the *Voice* but the *SoHo Weekly News*. In the image one saw Fred and Ginger impersonators kicking up their heels in front of a little sheet; you can see the "real" world a bit behind the backdrop. It's there that you see so much of Scott's brilliance coming into play—a brilliance I try to imitate or grab hold of when I take pictures sometimes, all those little peaks and valleys of reality and artificiality mixed together in the "fact" of the photograph. I don't know how much more I can say or want to say about what I felt about Scott's heart and what he showed me of it on and off the page, because even though he's dead I know he's still too tender for me to describe all that.

CIRCUS

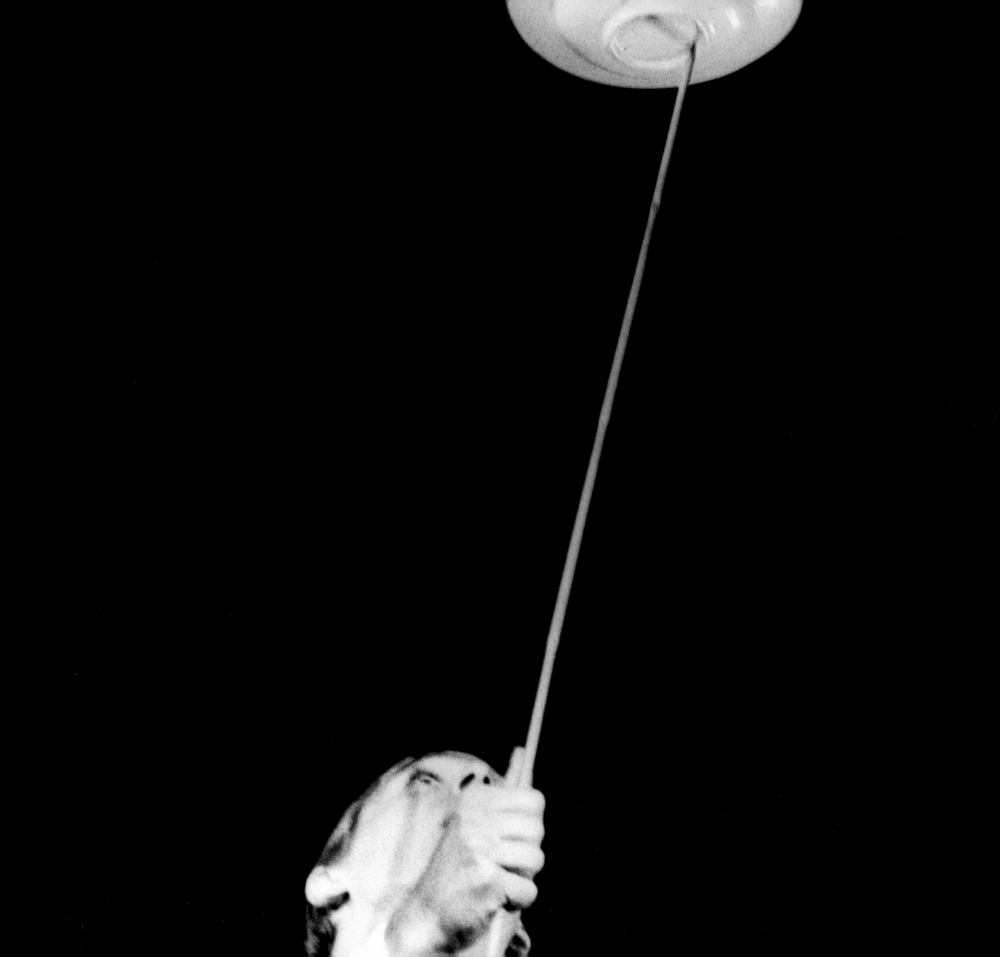

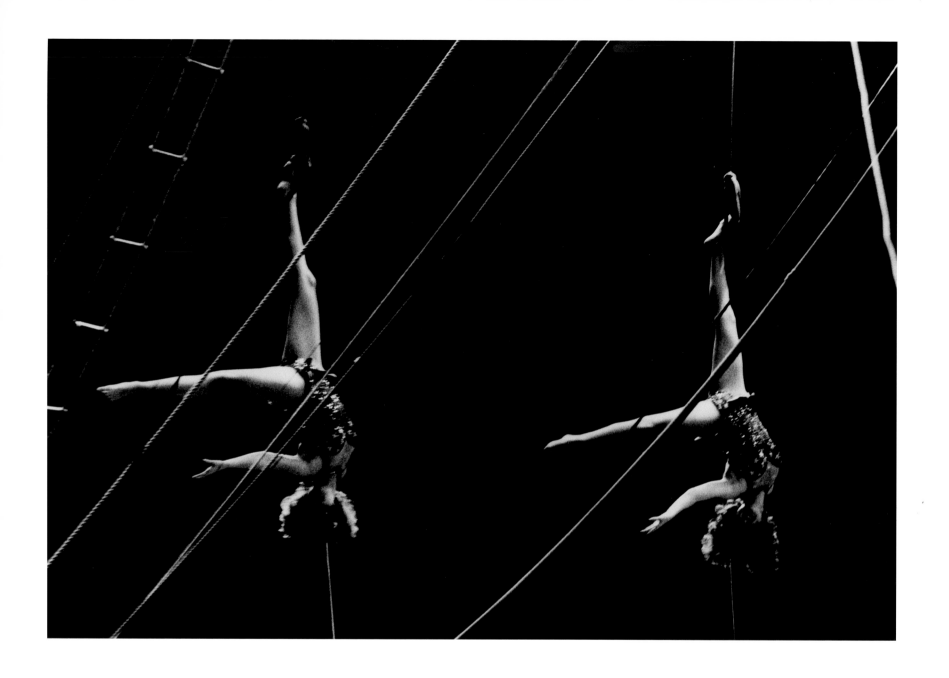

Plate 28　Scott Heiser, **Upside Down Girls, New York,** c. 1982

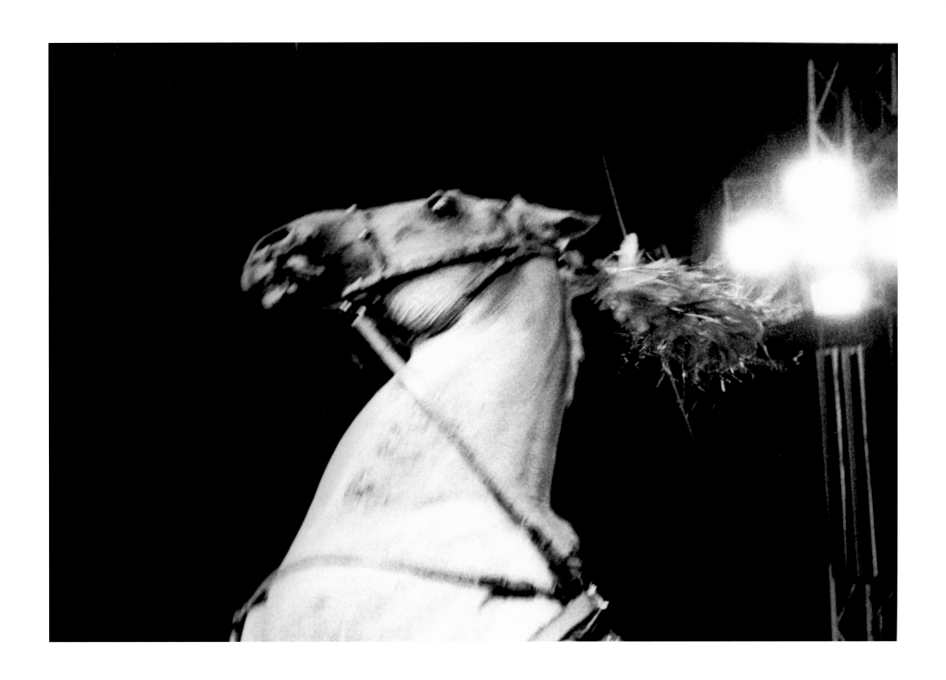

Plate 29 Scott Heiser, **Horse Head, Circo Nando Orfei, Milan,** c. 1982

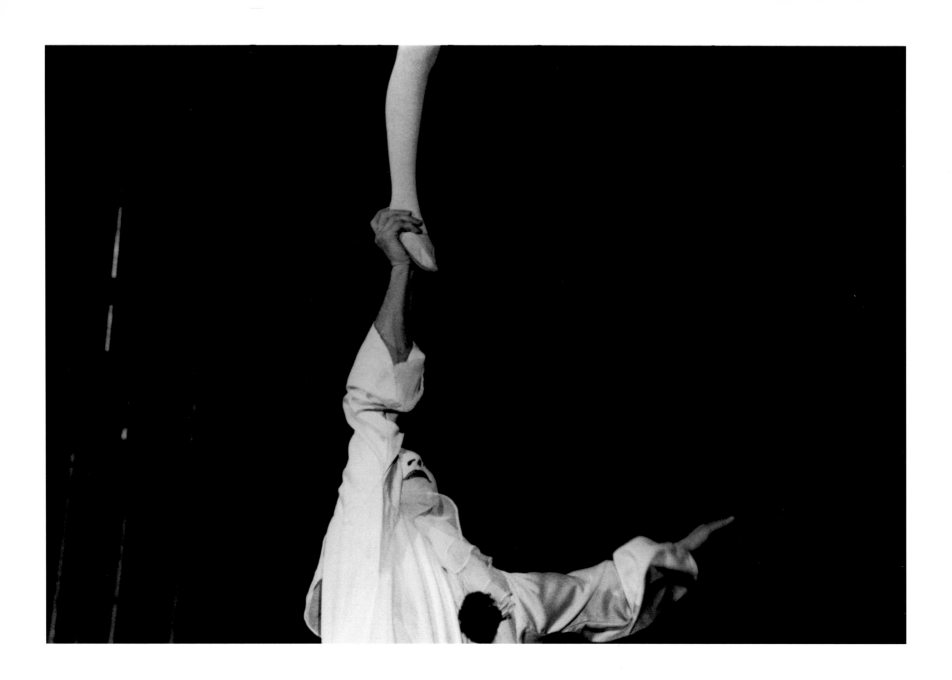

Plate 30 Scott Heiser, **Big Apple Circus, New York,** 1982

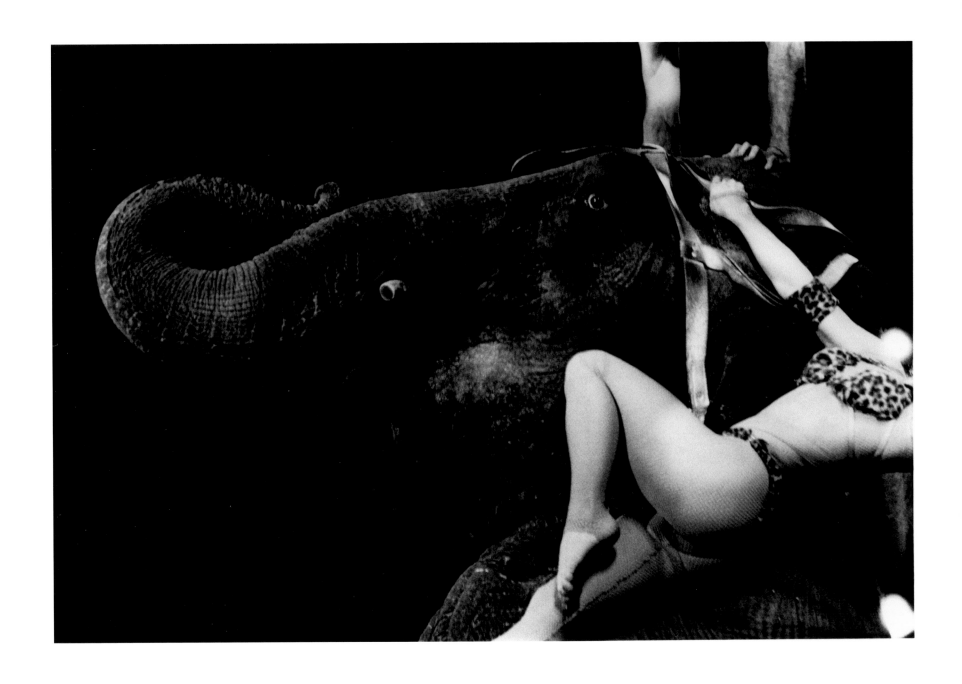

Plate 31 Scott Heiser, **Big Apple Circus, New York,** 1982

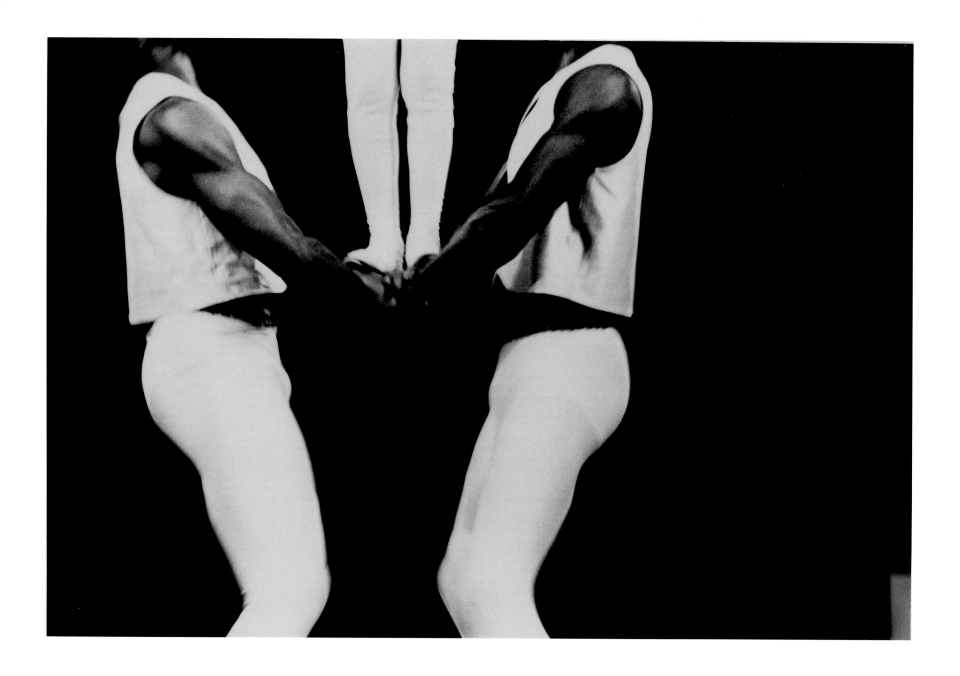

Plate 32 Scott Heiser, **Big Apple Circus, New York,** 1983

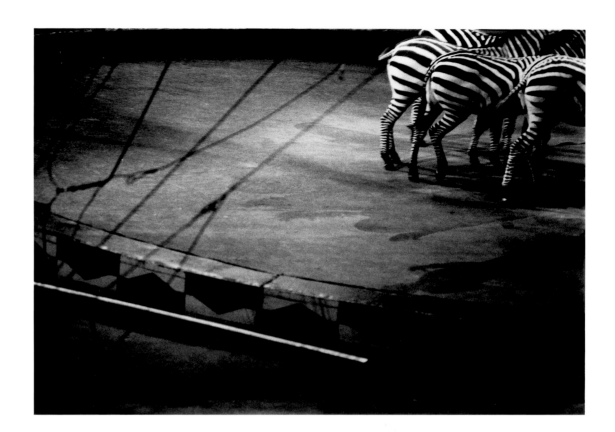

Plate 33 Scott Heiser, **Zebras, Ringling Bros. and Barnum & Bailey Circus,** c. 1988

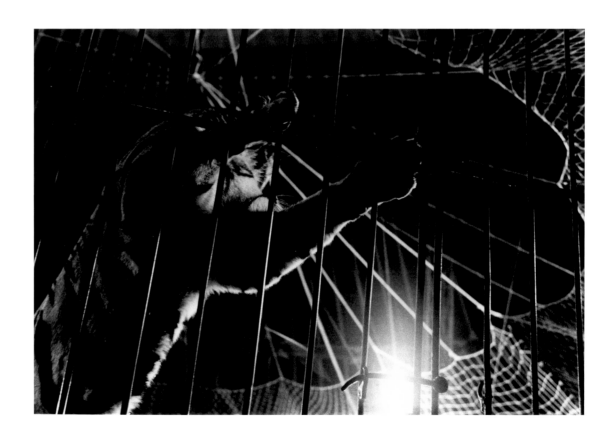

Plate 34 Scott Heiser, **Tiger,** not dated

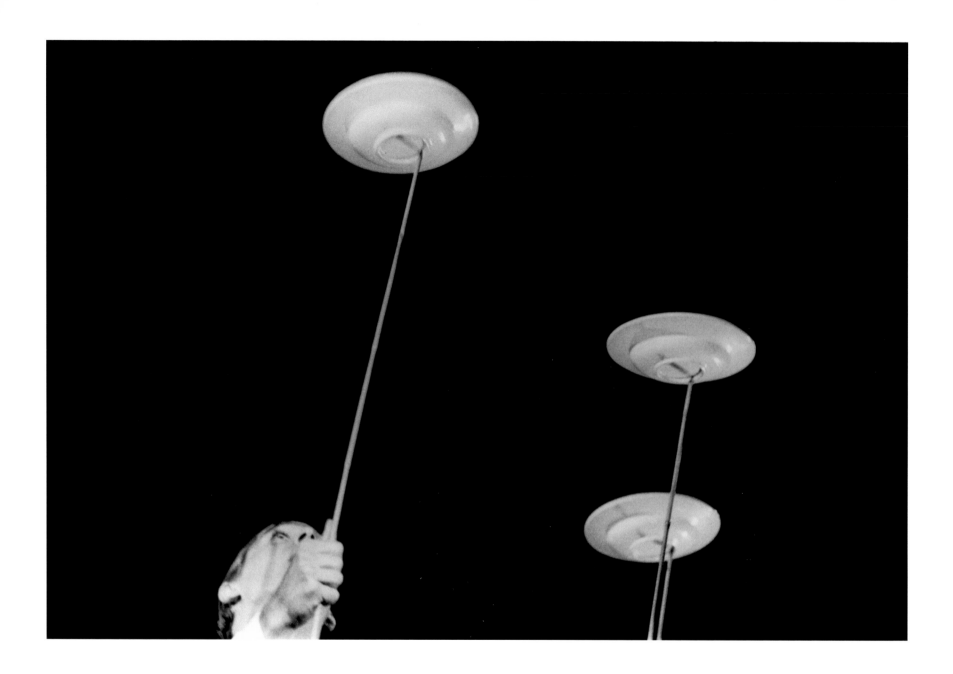

Plate 35 Scott Heiser, **Plate Spinner,** not dated

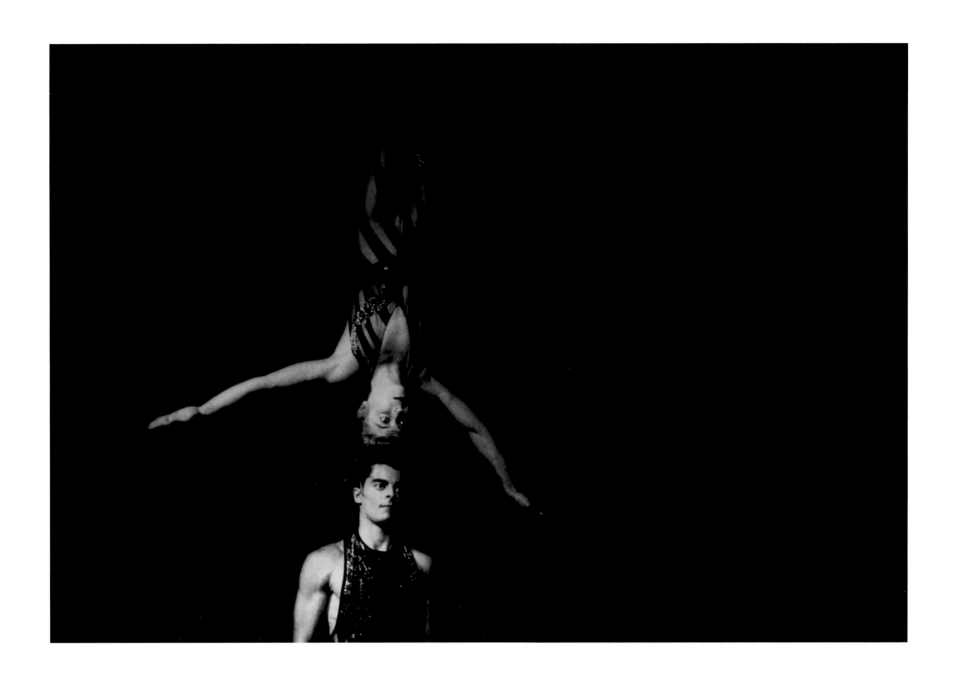

Plate 36 Scott Heiser, **Two Performers,** not dated

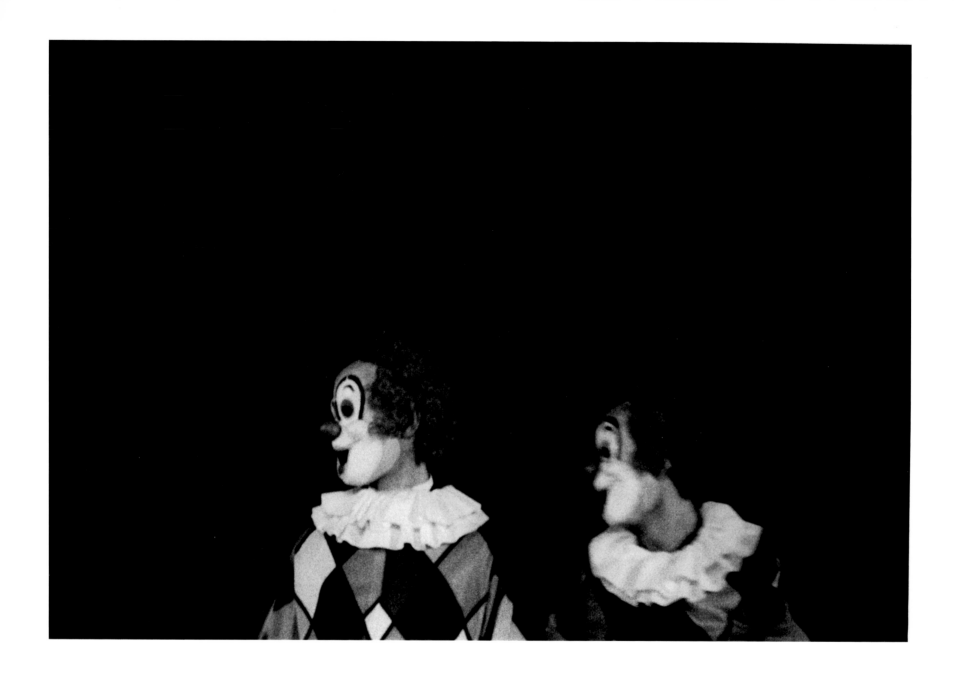

Plate 37 Scott Heiser, **Two Clowns, Paris,** 1986

Plate 38 Scott Heiser, **Circus Mat, New York,** 1990

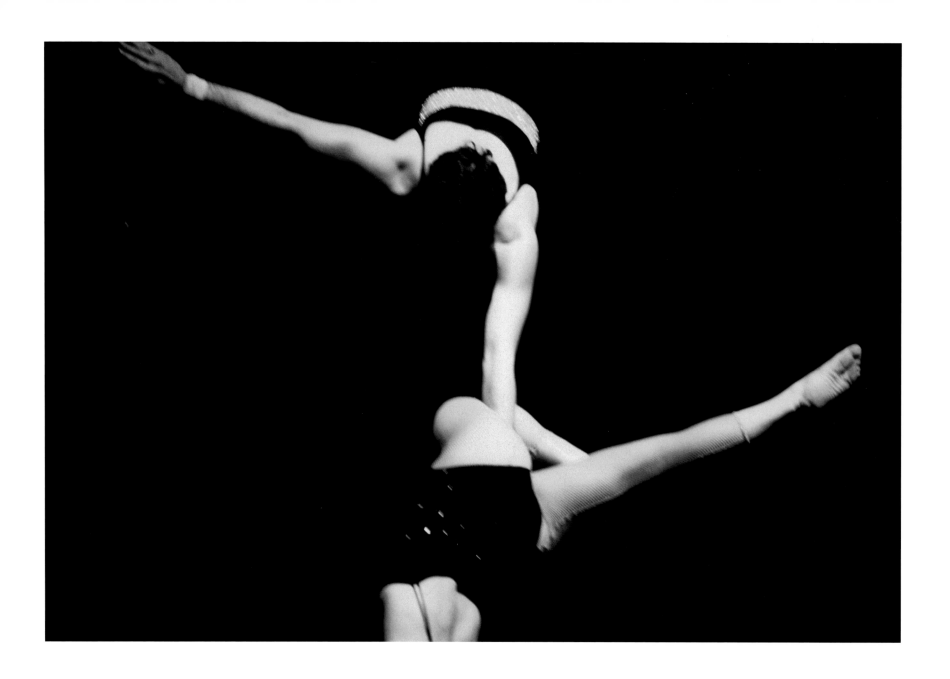

Plate 39 Scott Heiser, **Acrobats,** not dated

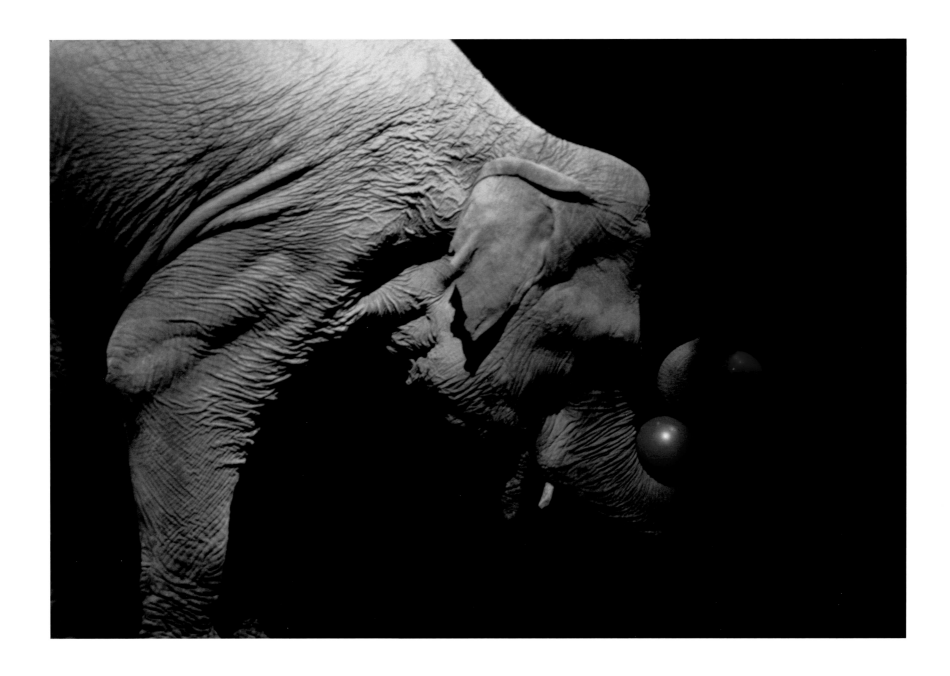

Plate 40 Scott Heiser, **Elephant,** not dated

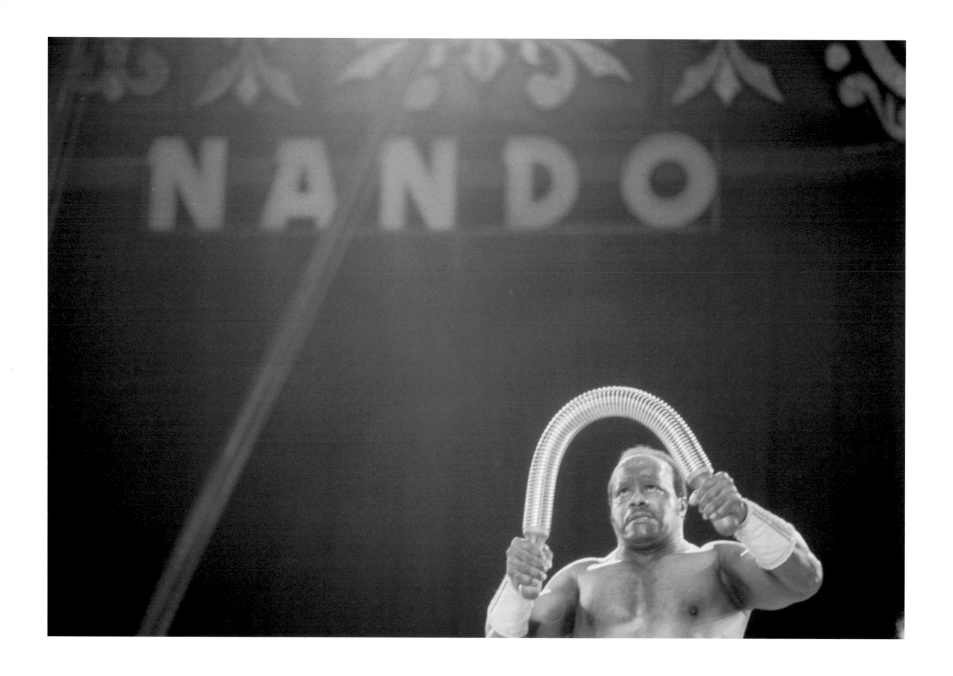

Plate 41 Scott Heiser, **Nando,** not dated

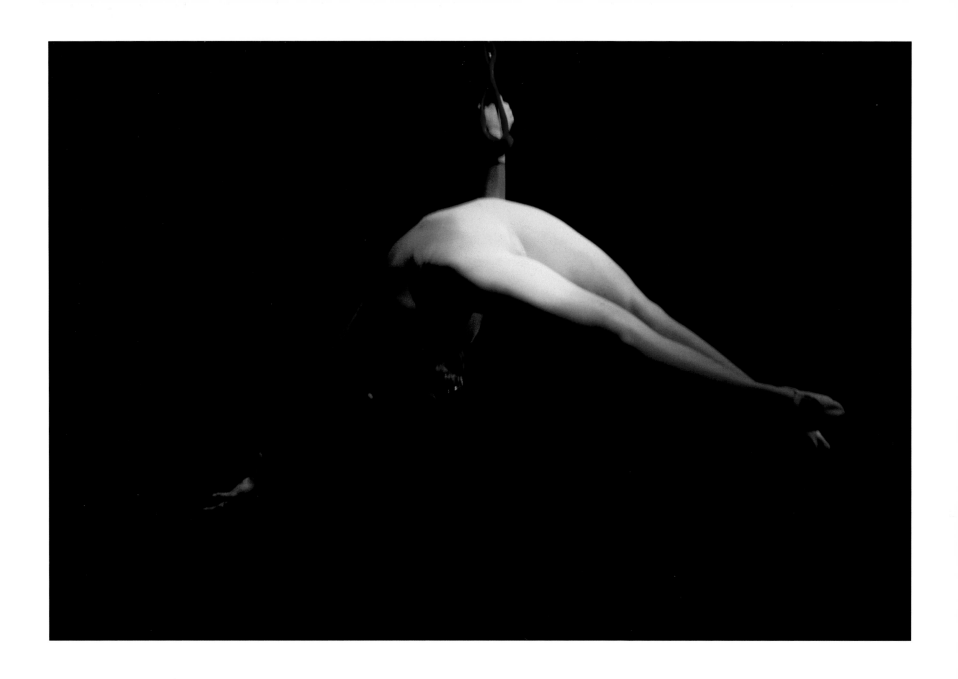

Plate 42 Scott Heiser, **Acrobat,** not dated

Odd Man Out THOMAS WOODRUFF

Scott was always being told that his work didn't quite fit. There was too much fashion for it to be art, and it was too arty to qualify as fashion. When I met him in the early eighties, he had already been shooting the shows and portraits for *Interview* magazine and piecing together odd assignments to earn a modest living. He kept his overhead low, and his equipment minimal. His bathroom was his lab, a closet his darkroom.

A fun evening in those days would be a to have a cheap meal of General Tso's chicken with vodka gimlets, and then to buy packs of old-fashioned black-and-white Polaroid film and wander around Greenwich Village. He would take pictures of me with graphic backgrounds at oblique angles until the light became too dim.

He hired me to assist him at many of the shows. "Assist" was not the right word, as I was too slow to load film at the speed he required. I was basically more of a bodyguard, there to protect his chosen spot on the runway and keep the other photographers at bay. I would later be shocked to see the contact sheets, and amazed at the images he made and the moments he caught. I was right next to him, but had totally missed what he had seen. It was often quite tense as the models would walk toward him, ready and eager for him to take their picture, and he

would wait, camera poised on his shoulder, smiling disingenuously, disinterested until they turned away . . . then he might shoot them—in the back. The traditionally pretty girls didn't have a chance. Scott was only interested in the oddballs, and he often gave his favorite models nicknames: "mosquito body," "dog-face girl," "Estelle Winwood," "bag-o-bones," "poison darts," "Madame X," "the cobra jewel," "big Gumby," and hilariously so on. The women who could really move across the runway, with the deliberateness of silent-screen stars—those creatures were golden! He couldn't care less about the clothes; it was all about shapes, the light and shade, and recording these amazing players in their strange ceremonies. He didn't speak at all during the show itself; it was almost as if he held his breath.

I took him to see the Chinese acrobats for his birthday. The City Center auditorium was almost empty. He pulled out his camera, surreptitiously shooting their ritualistic feats of balance and skill. The oddness appealed to him; the combination of futility and magic suited his sensibilities. Trips to the circus soon followed. Scott said that he wanted to capture the feelings of a sensitive child on its first visit to the Big Top, both awed and scared at the same time . . . and not really understanding the intended responses of the mysterious show of glitter and darkness. He loved the European circuses because they were even more indecipherable and inscrutable. The images he created are rather disorienting and oddly exhilarating, being so close-up and off-moment. They burn into the brain and get under the skin, like a fever dream. I can't step foot in a circus now without Scott sitting wraithlike beside me, anxiously awaiting the bead of sweat to appear on the head of the contortionist or the crack in the greasepaint of a vicious white clown chasing a honking goose.

Years later, when Scott was diagnosed with AIDS, his carefree nature was shattered. His best friend Gerald had died quickly, and we all witnessed our buddies and colleagues die in very unpleasant and downright surrealistic ways. The treatment was pretty brutal, and the outcome was always certain. Scott became more hermetic, socialized less, and turned away from promoting his commercial career. He took up proofreading at night to pay his bills, and by day set out on his mission to record the world that he still didn't understand, and which didn't understand him very well. From the outside, his "Events" pictures could seem like a variant on *The Family of Man,* the feel-good collection of Edward Steichen's landmark Museum of Modern Art photography show (and book) from 1955. But from the inside these images are the poem of a man who knew he had little time and a lot to process and witness.

I find it so poignant to know that he would shoot the Harlem Boys Choir in the day, and then go home to do his drip of medication through the port placed in his side that night. He traveled to the Miss America

Boardwalk Parade in Atlantic City and photographed a shining boy and girl in profile in the warm sun of late summer, when they didn't know his secret. He fixated on shooting group activities, people working and exercising in unison, when he personally must have felt isolated and solitary: an act of magical thinking perhaps. There is a bittersweet distance to these images, made with an alien eye, and a wistfulness that feels palpable. Sometimes the fear and hopelessness appear in focus, as when he trained his lens on the synchronized swimmers... desperate awkward arms protruding from the greasy gray pool: Miss Esther Williams, may I introduce Mr. Samuel Beckett.

He shunned the VIP passes that got him into the elite fashion shows then, and he bought his ticket to the children's ballet recital in Chinatown like everyone else. He had no real reason for being there... except to record the emotion and frailty, and to gather and collect the delicate strands of what it is like for all of us to be alive. A taut torso of a greyhound, a single plane with a plume of exhaust, a svelte sword swallower, an amateur archery demonstration, imperfect Fred and Ginger impersonators, papier-mâché-headed pigs on skates, a flock of scattering dark birds—there are all the chords, played in minor keys on the strings of his heart. It is Scott's last song... catchy, memorable, and profound... with all the solemnity of the "Dies Irae" and the familiarity and celebration of "Happy Birthday."

FASHION CIRCUS **SPECTACLE**

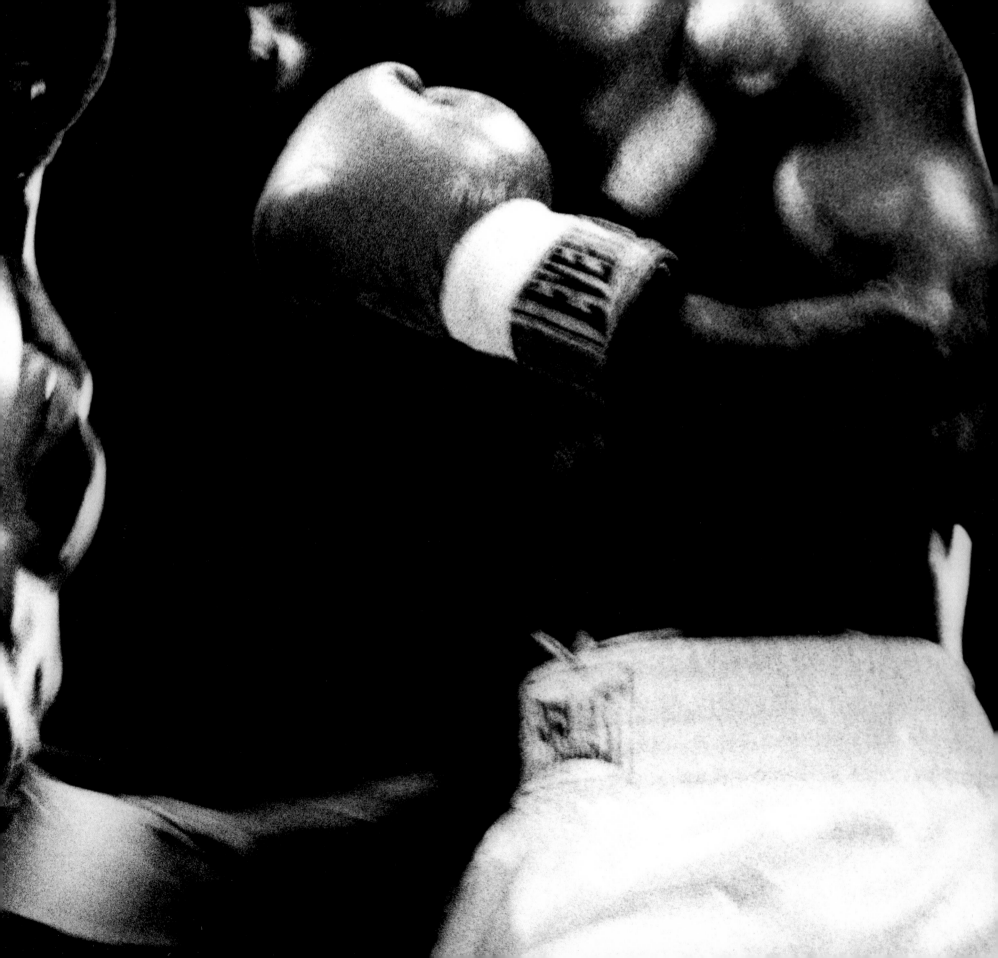

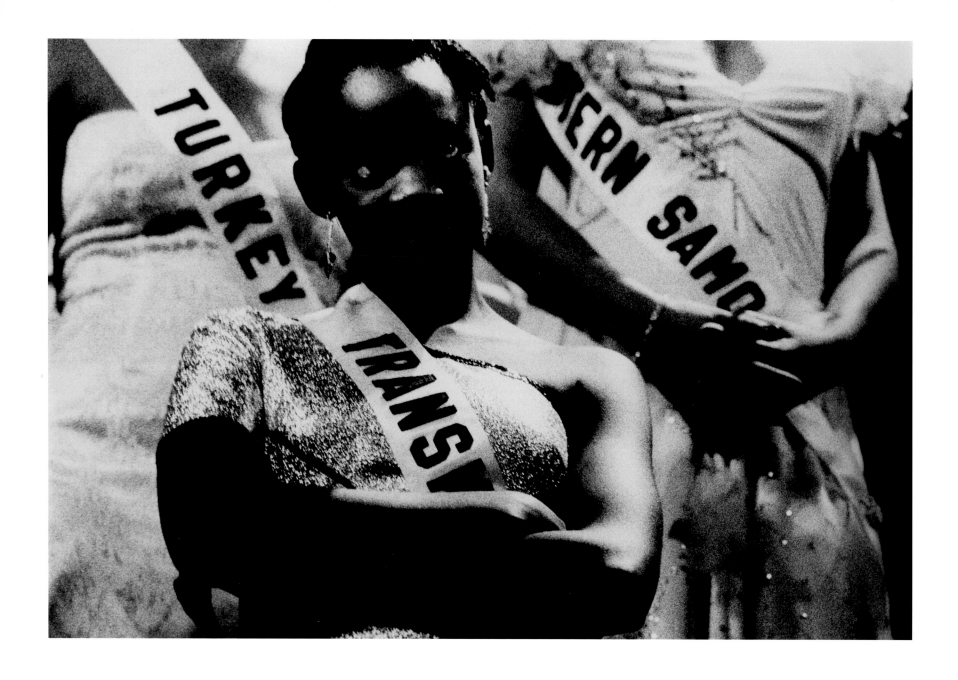

Plate 43 Scott Heiser, **Beauty Contestant, New York,** 1981

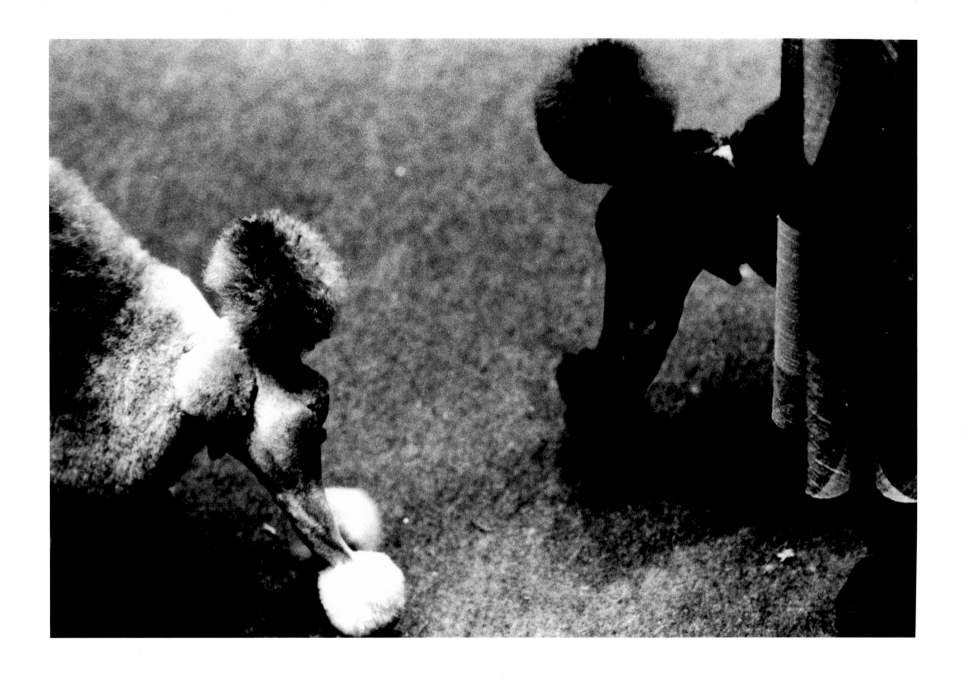

Plate 44 Scott Heiser, **Two Poodles, Westminster Kennel Club Dog Show,** 1985

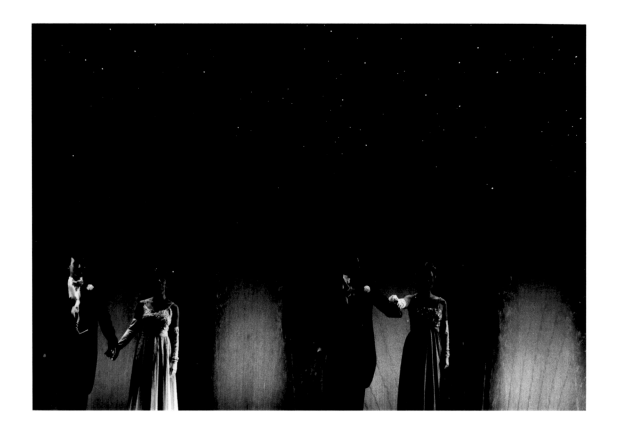

Plate 45 Scott Heiser, **Two Couples, New York,** c.1985

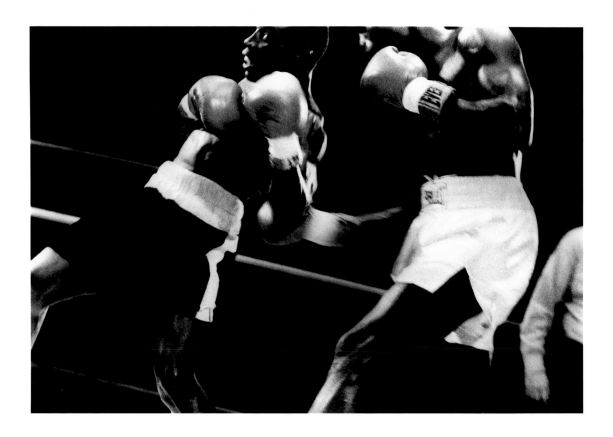

Plate 46 Scott Heiser, **Boxers,** c. 1986

Plate 47 Scott Heiser, **National Sportsmen's Show, Javits Center,** 1988

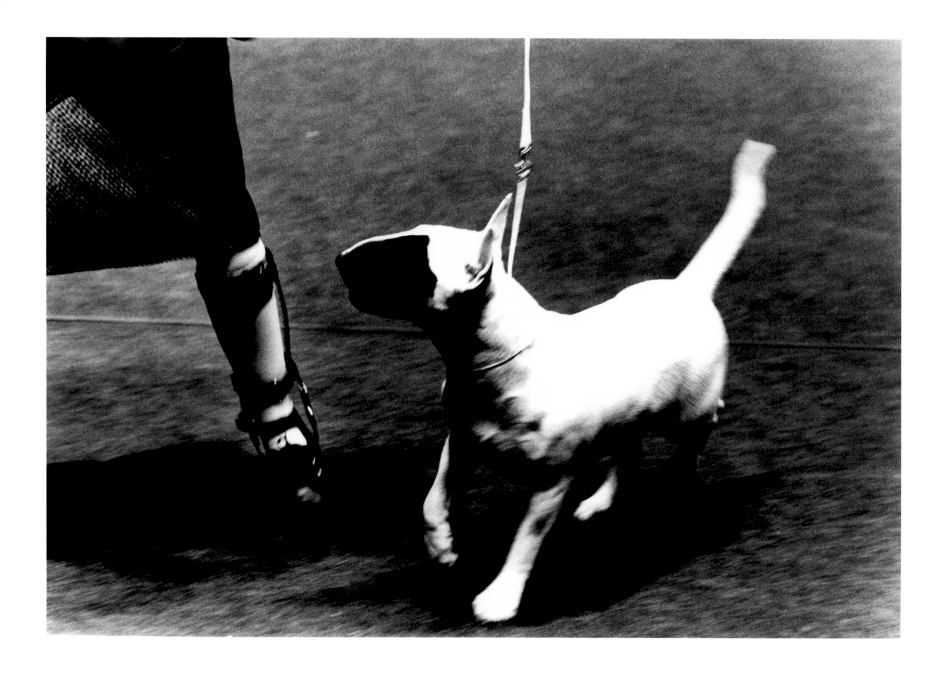

Plate 48 Scott Heiser, **Bull Terrier, Westminster Kennel Club Dog Show,** 1988

Plate 49 Scott Heiser, **Swedish Gymnasts Federation, World Trade Center,** 1988

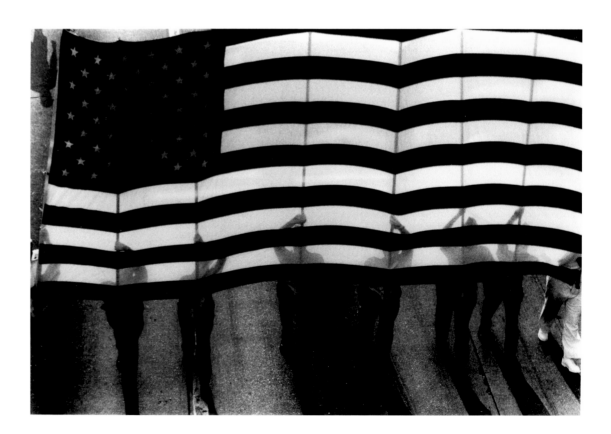

Plate 50 Scott Heiser, **American Legion Parade, Baltimore,** 1989

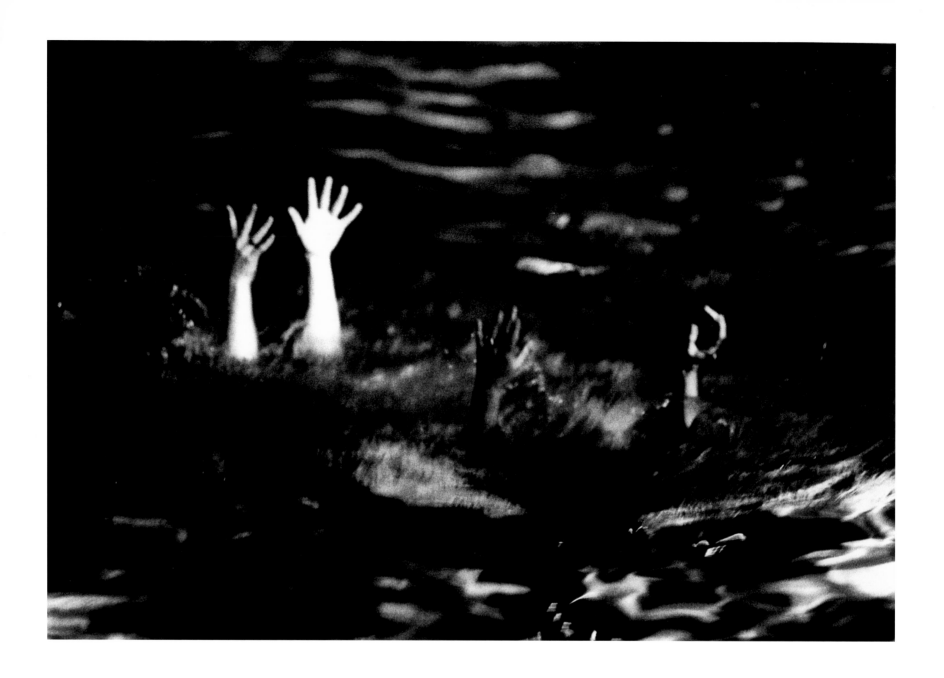

Plate 51 Scott Heiser, **Synchronized Swimmers,** 1989

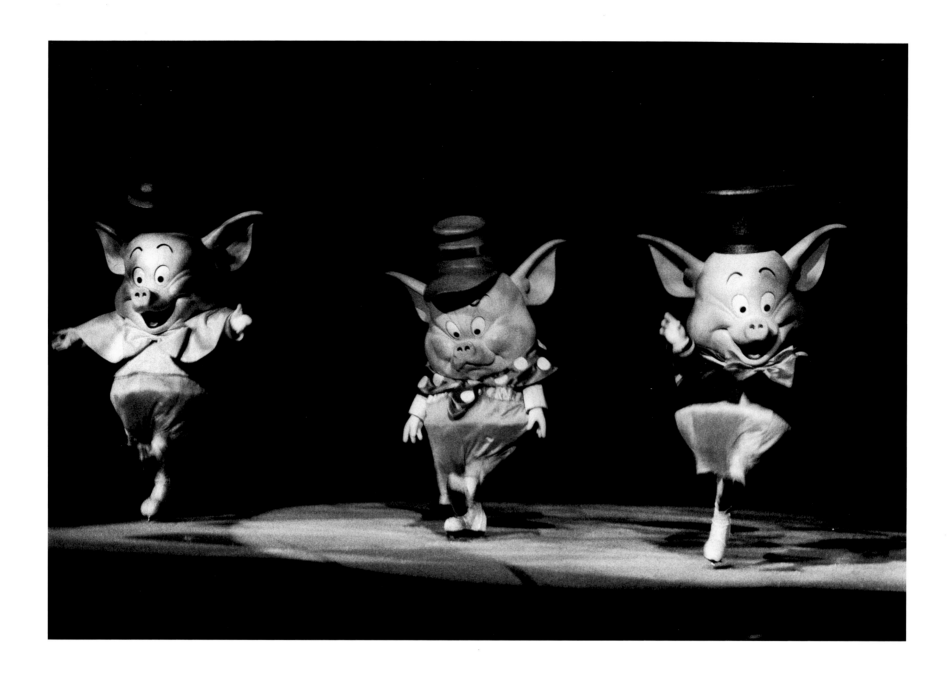

Plate 52 Scott Heiser, **Pigs on Skates,** 1989

Plate 53 Scott Heiser, **Recital, Lee Ballet School,** 1991

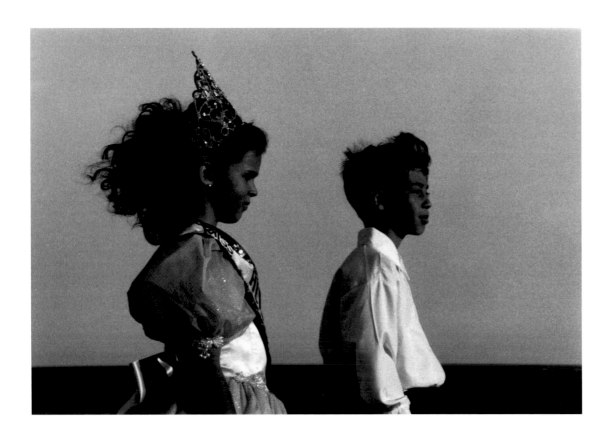

Plate 54 Scott Heiser, **Miss America Parade, Atlantic City,** 1991

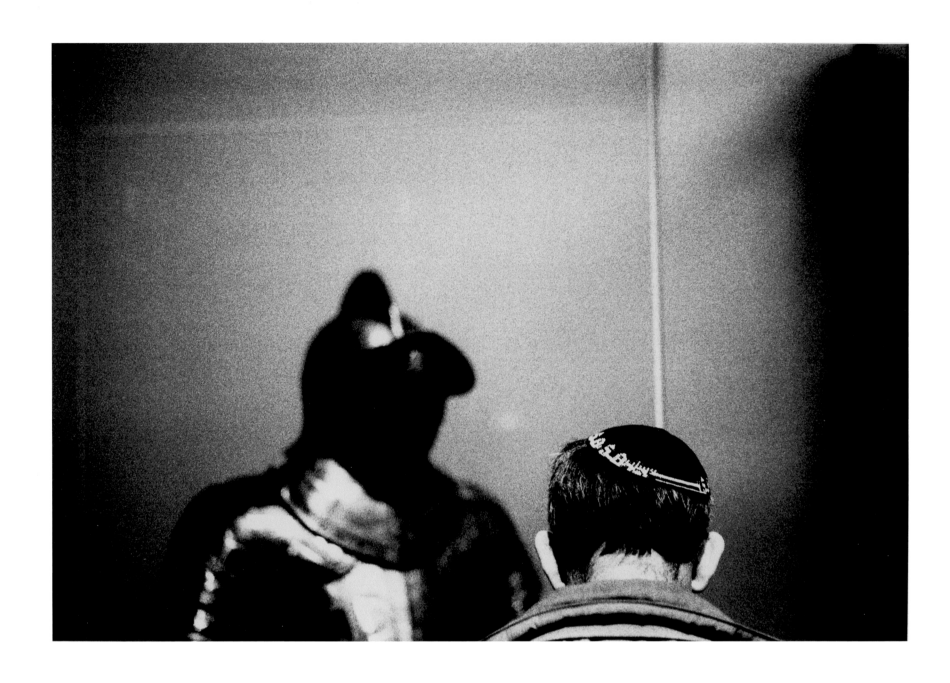

Plate 55 Scott Heiser, **Helmet, Metropolitan Museum of Art,** 1993

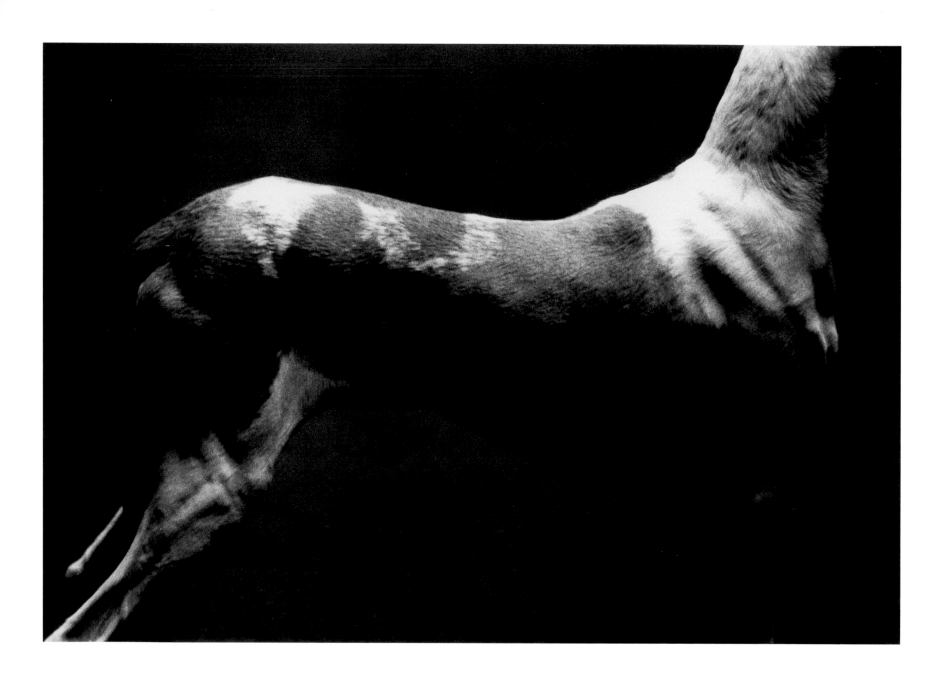

Plate 56 Scott Heiser, **Female Nude,** 1993

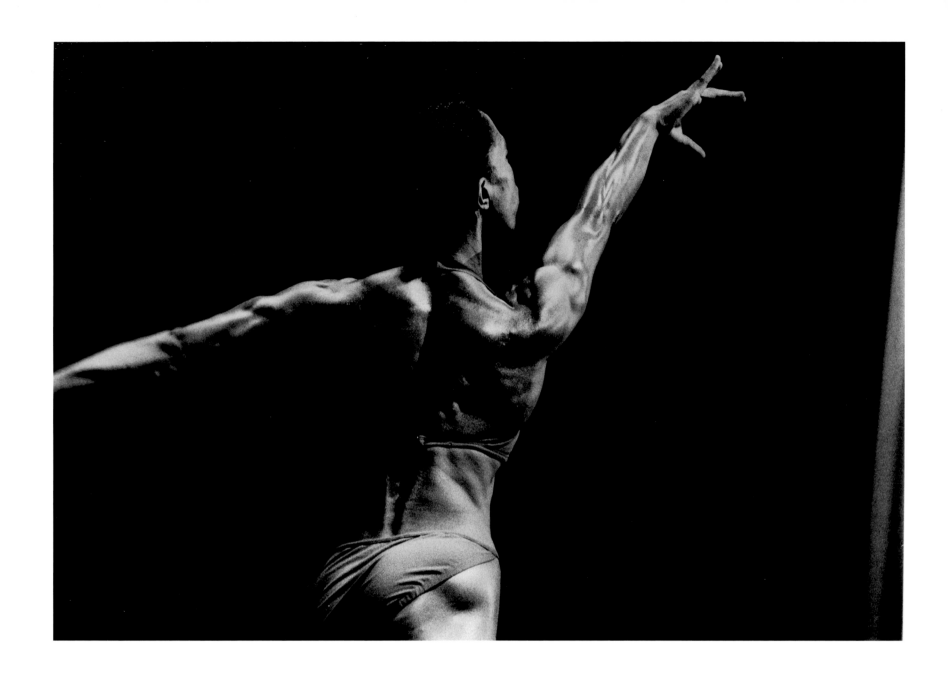

Plate 57 Scott Heiser, **Female Torso, New York,** not dated

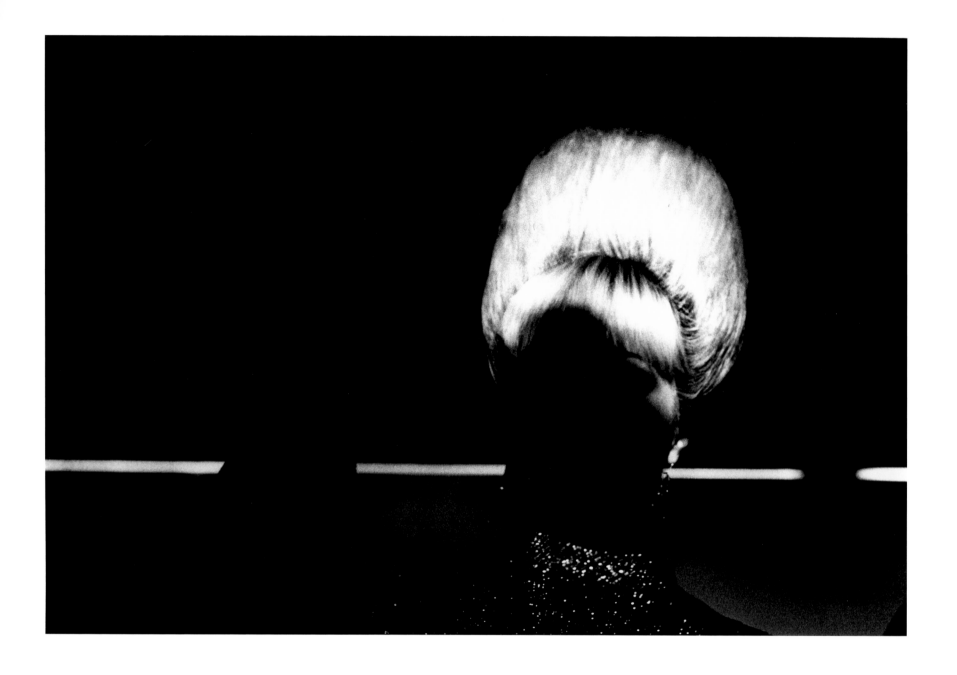

Plate 58 Scott Heiser, **Bee Hive, New York,** not dated

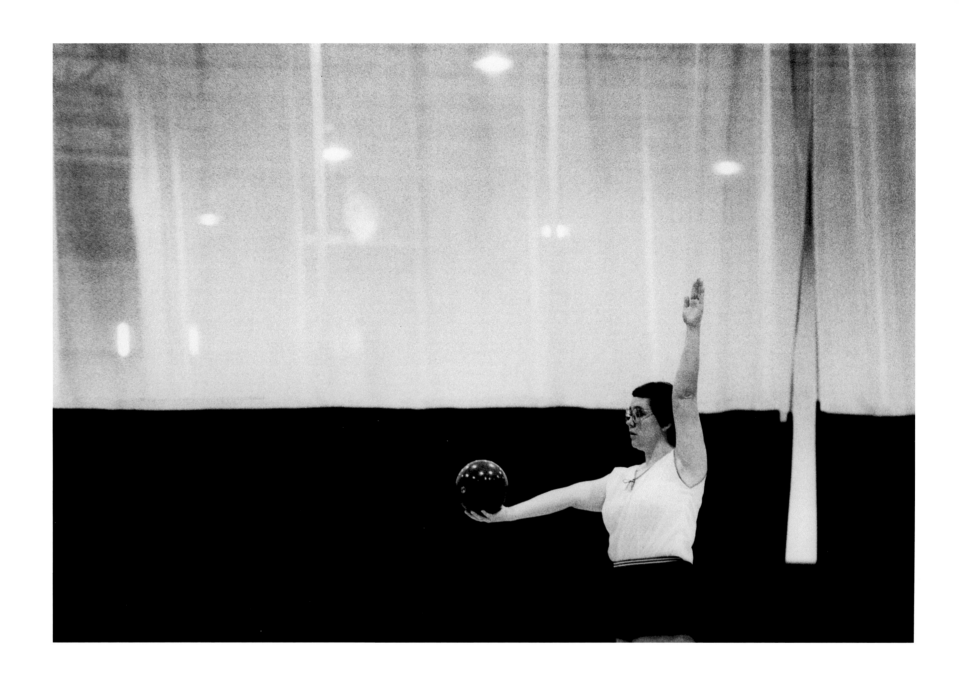

Plate 59 Scott Heiser, **Sokol Slets,** not dated

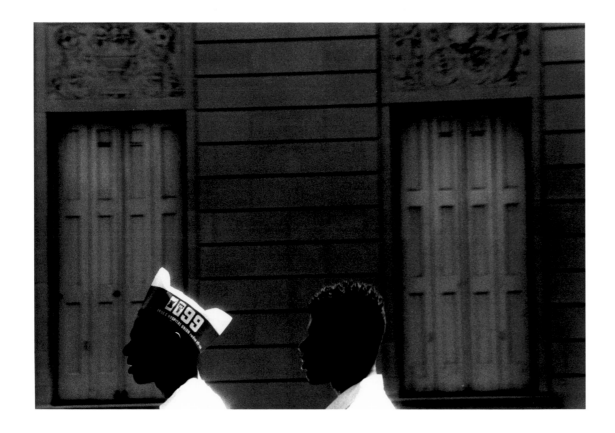

Plate 60 Scott Heiser, **Men at a Parade,** not dated

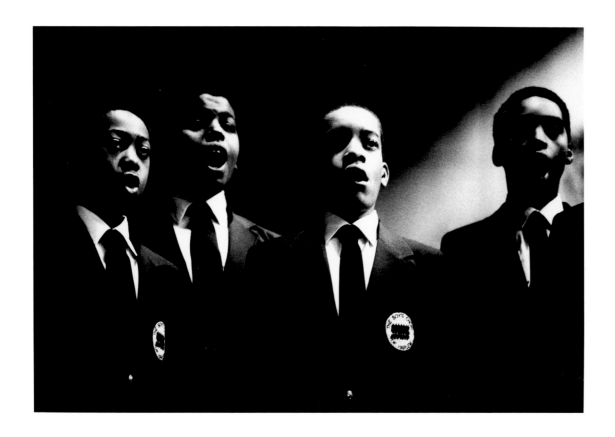

Plate 61 Scott Heiser, **Singing Boys, New York,** not dated

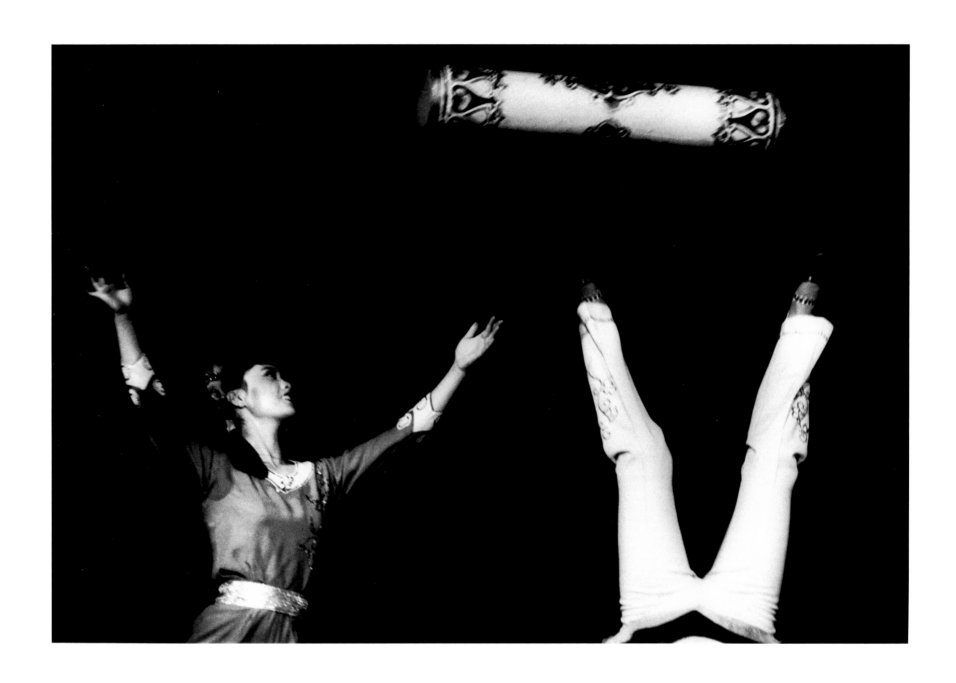

Plate 62 Scott Heiser, **Two Halves, New York,** not dated

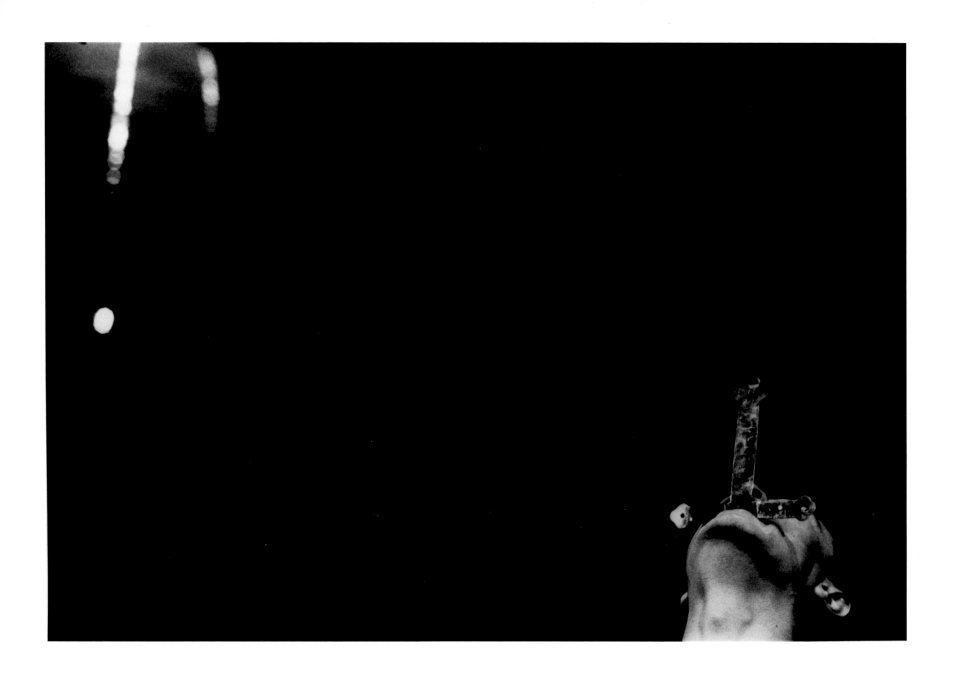

Plate 63 Scott Heiser, **Sword Swallower, New York,** not dated

Plate 64 Scott Heiser, **Birds in the Sky,** not dated

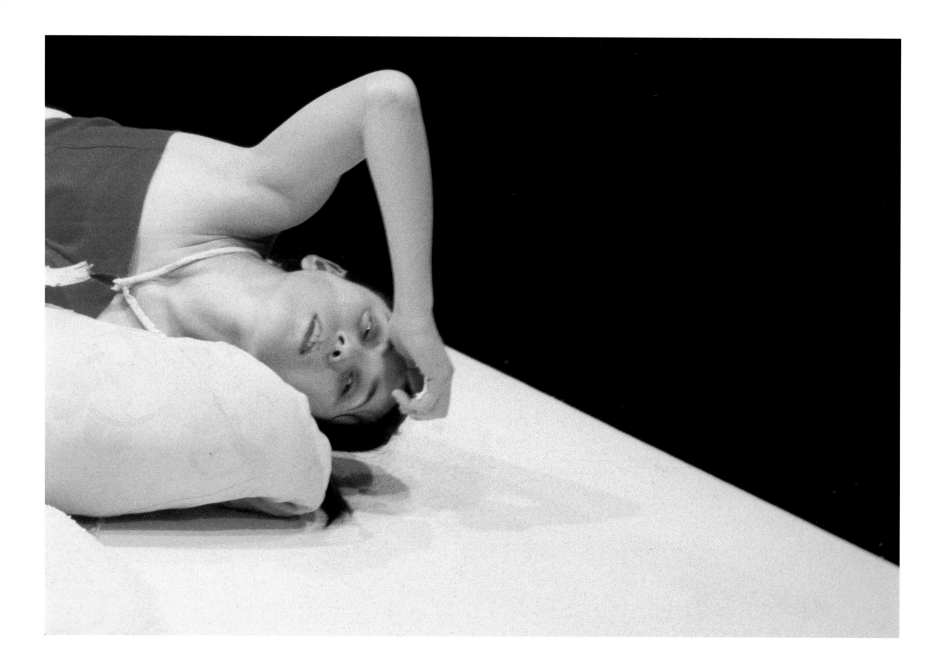

Plate 65 Scott Heiser, **Eiko,** 1990

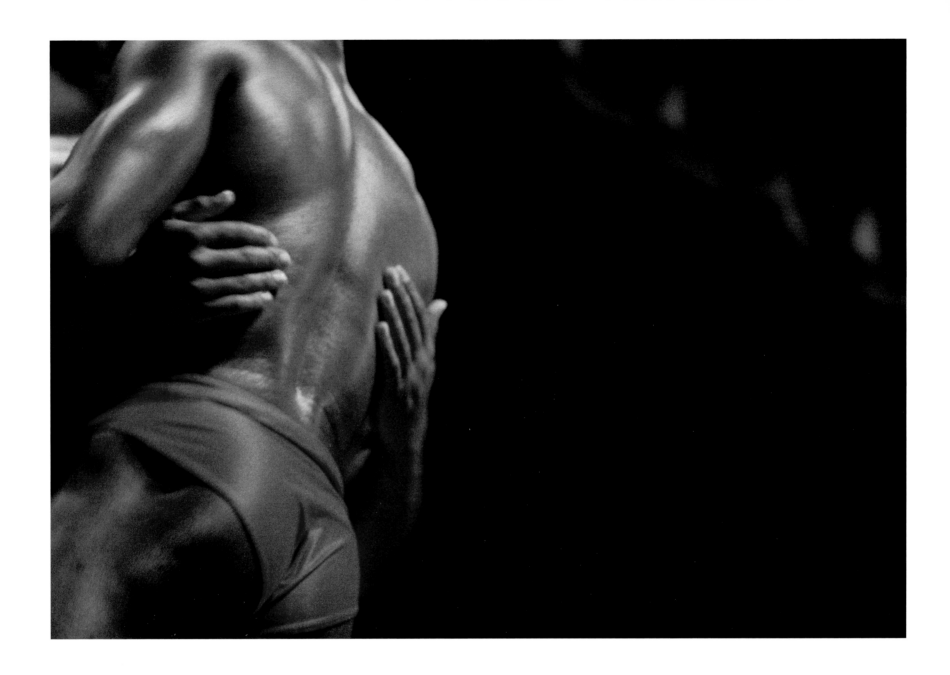

Plate 66 Scott Heiser, **Body Builders,** not dated

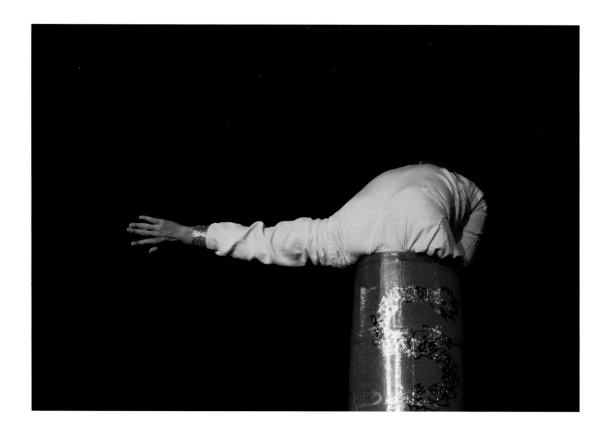

Plate 67　Scott Heiser, **Chinese Acrobat,** not dated

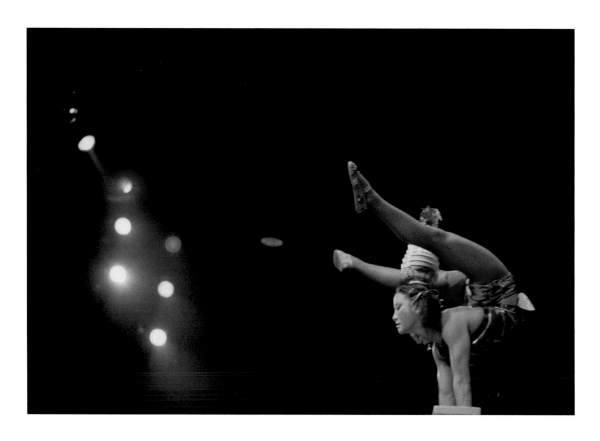

Plate 68　Scott Heiser, **Chinese Acrobat,** not dated

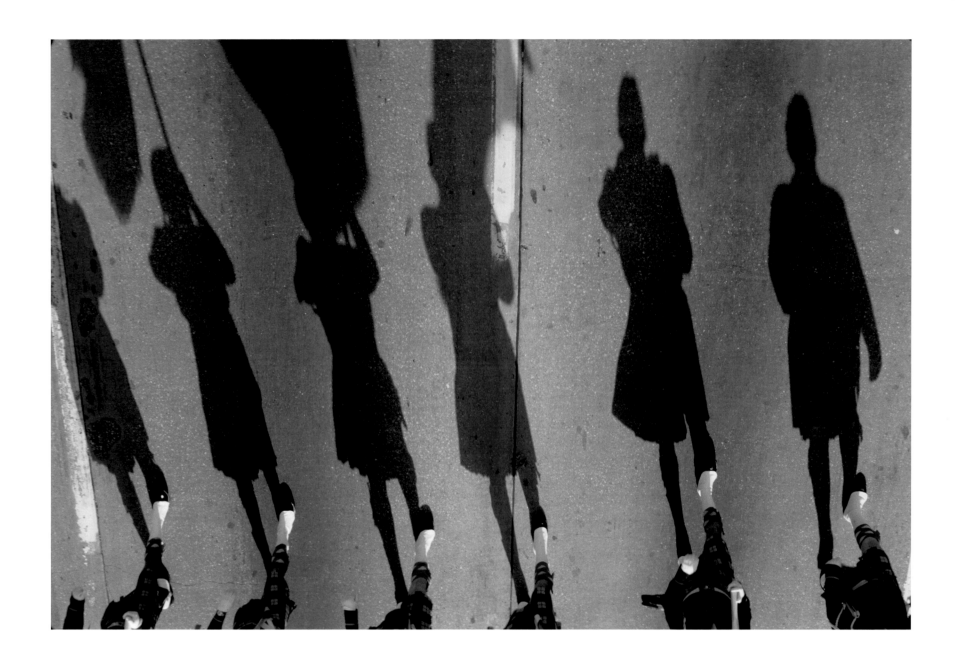

Plate 69 Scott Heiser, **Parade,** not dated

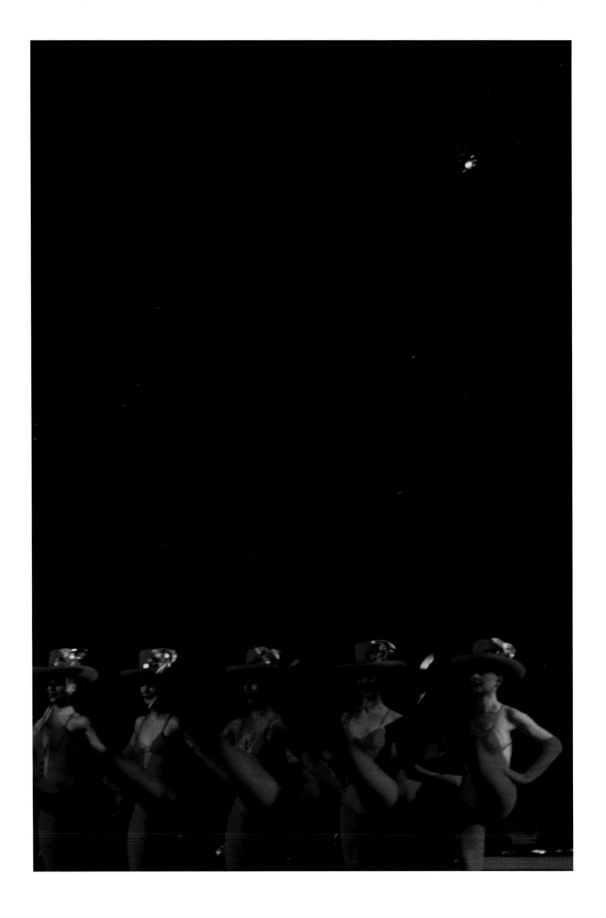

Plate 70 Scott Heiser, **Rockettes,** not dated

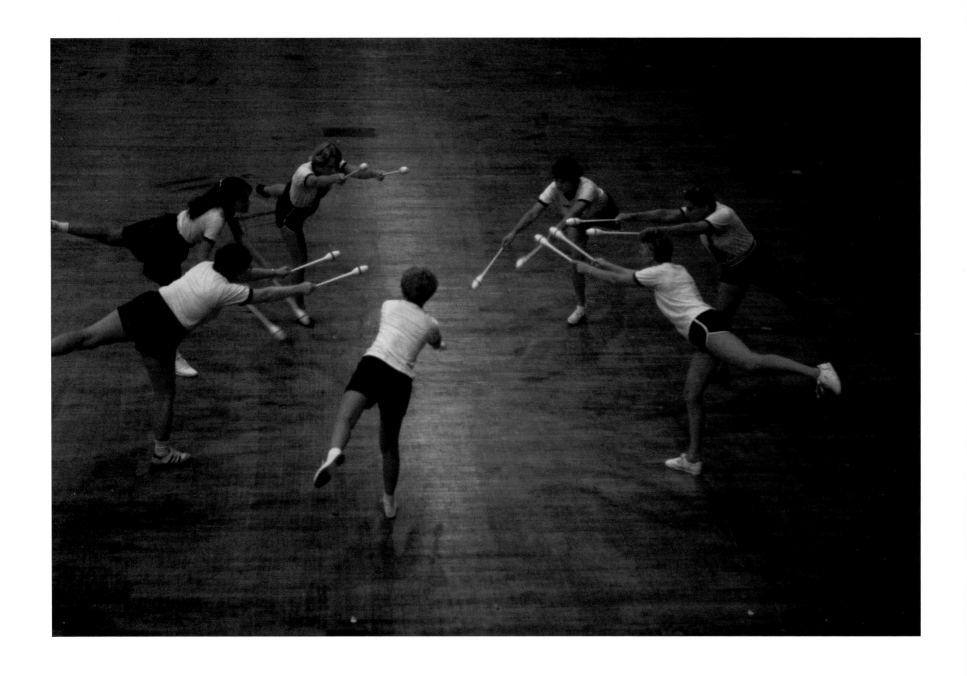

Plate 71 Scott Heiser, **Sokol Slets,** not dated

Chronology

Carson Zullinger, **Badges and Press Passes from Scott Heiser Papers, Delaware Art Museum,** 2013.

March 12, 1949: Scott Thomas Heiser born, Wilmington, Delaware.

1967: Enters Rhode Island School of Design as a graphic design major.

1971: Graduates with Bachelor of Fine Arts degree in Photography from RISD. Moves to New York City.

1971–73: Works as an assistant to Steen Svensson.

1972: First paid commission, a portrait for "Taxi!" by Trucia Kushner, appears in Andy Warhol's magazine *Interview*.

1973–75: Works as an assistant to Deborah Turbeville.

1974: Work published in *35mm Photography* and *Invitation to Photography,* two magazines produced by Ziff Davis, publishers of *Popular Photography*. Interviews and photographs Jamie Wyeth for *Interview*.

1975: Prints photographs from negatives in the collection of the Museum of Modern Art, New York, for *Six Decades of Fashion Photography* at the Emily Lowe Gallery of the Hofstra University Museum, Hempstead, New York.

1975–76: Contributing photographer for *SoHo Weekly News*.

Carson Zullinger, **Badges and Press Passes from Scott Heiser Papers, Delaware Art Museum,** 2013.

1976: Work appears in *Interview, New York Magazine, SoHo Weekly News, New York Times, Mademoiselle,* and *Ms.* Profiled in *Art Direction.*

1979: Appears on first episode of Andy Warhol's cable television show *Fashion.* Work appears in eighteen publications including *New York Rocker, Ritz, Women's Wear Daily, Vogue, Harper's Bazaar,* and *Esquire.*

1982: Profiled in *American Photographer* and *Zoom.* Ten works included in the exhibition *Faces Photographed: Contemporary Camera Images* at the Grey Art Gallery of New York University. Works included in *Five Interview Photographers* at the Govinda Gallery, Washington, DC, and *Silhouettes of Style* at the Hudson River Museum, Yonkers, New York. Portfolio of circus pictures appears in *Creative Camera.*

1983: Exhibits work at the Chicago Press Club and the Hokin-Kaufman Gallery, Chicago. Work appears in eight publications including *East Village Eye, Women's Wear Daily,* and *G.Q.*

1985–88: French Cultural Services circulates an exhibition of Heiser's fashion photographs.

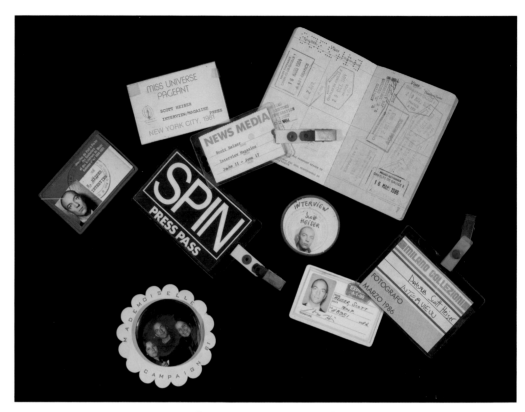

Carson Zullinger, **Badges and Press Passes from Scott Heiser Papers, Delaware Art Museum,** 2013.

1986: Included in exhibition *Next from New York 10* at the Tokyo Design Space-Axis, Japan.

1987: Four photographs by Heiser appear in Richard Martin's *Fashion and Surrealism,* a publication produced in association with an exhibition at the Fashion Institute of Technology, New York, and the Victoria and Albert Museum, London.

1986–93: Contributing photographer for *Paper.*

1988: Work appears in thirteen publications including *Redbook, Spin, Details,* and *Marie-Claire (Japan).*

March 1989: Solo exhibition at the Paula Allen Gallery, New York.

1991: Portfolio appears in *Shiny: The Magazine of the Future.* Exhibition opens at the Midtown Y Photography Gallery, New York.

1992: Work appears in six publications including *NYQ, Elle (Japan),* and *Village Voice.*

October 21, 1993: Dies, New York City.